IMAGES
of Modern America

SEATTLE's 1962
WORLD's FAIR

CENTURY 21 EXPOSITION, INC., *presents*

SEATTLE WORLD'S FAIR

April 21 to October 21, 1962 Seattle, Washington, U.S.A.

"A ticket to tomorrow"

President

A 269939

Welcome to the Fair!

This ticket to tomorrow will enable you to enjoy the many unique adventures of Seattle's Space Age World's Fair. Each Century 21 host and hostess is eager to assist in providing you with a day of fun and excitement in the "Wonderful World of Tomorrow." We hope that your day will be a memorable one and that we may have the pleasure of entertaining you many times in the future.

President

FRAYN

A ticket to the 1962 World's Fair was a passport to many worlds. Visitors could explore exhibits on science, new products, and international cultures, as well as a wide variety of shows and the latest in carnival rides.

ON THE FRONT COVER: Clockwise from top left: Space Needle, symbol of the fair (author's collection), Electricab taxi passing the Fine Arts Building (author's collection), Fiesta Restaurant (author's collection), *It's the Water* show (author's collection), and arches of the US Science Exhibit (author's collection).

ON THE BACK COVER: From left to right: General view of the fair site (author's collection), the famous Bubbleator elevator (author's collection), and Electricab at the monorail terminal (author's collection).

IMAGES
of Modern America

SEATTLE'S 1962 WORLD'S FAIR

Bill Cotter

ARCADIA
PUBLISHING

Published by Arcadia Publishing
Charleston, South Carolina

Printed in the United States of America

Library of Congress Control Number: 2015948004

For all general information, please contact Arcadia Publishing:
Telephone 843-853-2070
Fax 843-853-0044
E-mail sales@arcadiapublishing.com
For customer service and orders:
Toll-Free 1-888-313-2665

Visit us on the Internet at www.arcadiapublishing.com

*To Carol: thanks for letting me fill the house with
photos, for your invaluable editing assistance,
and most of all, for your much appreciated support.*

CONTENTS

ACKNOWLEDGMENTS

It is always daunting to write a new book. At first, there is the question as to whether there will be enough material. Later, that always seems to evolve into making decisions on what to cut to fit in the allotted space. In doing this one, there was the added challenge of not repeating any photographs used in my first book, Images of America: *Seattle's 1962 World's Fair*.

Happily, I had some welcome help in taking care of these problems. I am honored to count Albert Fisher among my friends. Albert was hired at age 20 as the director of television and motion pictures for the Century 21 Exposition. Working at the fair must have been an incredible experience for him; Albert went on to a similar position at the 1964–1965 New York World's Fair, followed by an Emmy Award–winning career worthy of its own book. Albert graciously helped me with the research and contributed some very rare pictures of the fair.

On the subject of photographs, as with my other books, I have avoided the use of publicity photos and instead used images taken by actual visitors to the fair. I enjoy the sense of intimacy and excitement these candid shots bring; I hope you will as well.

Thanks also to Dean Nissen, Bill Crossman, and especially Deanne Charlton, all avid collectors and experts on all things associated with the fair. Their fact-checking and editorial advice is greatly appreciated. I also have to thank the wonderful team at Arcadia Publishing for their encouragement on the project, especially Erin Vosgien and Ginny Rasmussen.

The biggest thanks of all have to go to my wife, Carol. I would like to think I am a good writer, but her detailed review of my initial drafts is an invaluable help in many ways. Sometimes a writer will make assumptions that people are as familiar with the topic as they are, and she has helped set me straight on that more than once. She has also helped turn my punctuation and grammar into a form more likely to pass muster with the editors. Perhaps best of all, she encourages me to enjoy my passion for world's fairs.

Unless otherwise noted, all photographs are from the author's collection.

INTRODUCTION

On April 21, 1962, the gates of the 1962 World's Fair swung open, and by the time they closed forever on October 21, more than nine million visitors had toured the 74-acre site. Most of them probably never realized how much the fair had changed from the initial plans to what became reality.

The fair owed its birth to an interesting combination of events. The first could be linked to an earlier Seattle fair, the Alaska-Yukon-Pacific Exposition of 1909, which was held to celebrate the Yukon Gold Rush. That fair had made a big impression on a teenager worker, Al Rochester, who decades later became a member of the Seattle City Council and a newspaper publisher. A tireless civic booster, Rochester was the first to suggest that Seattle hold a new world's fair in the hope of attracting attention to the region. His plan was for the Exposition of the West to be held on the 50th anniversary of his beloved 1909 exposition.

Quite a few other leaders were also interested in holding a fair, but most were not driven by the same nostalgic urges as Rochester. Their major impetus was looking for a solution to two economic shortcomings that, they felt, were keeping Seattle from becoming a larger player in the business marketplace. Interestingly, both of the perceived problems were connected to the aircraft industry.

In the 1950s, Seattle was the headquarters of the Boeing Company, founded there in 1910. Over the years, Boeing had become one of the largest employers in the area, but the cyclical nature of its business had, at times, led to economic slumps when the company was forced to reduce its workforce. Many city and business leaders were determined to attract other companies to the area so the region's economy would not be so closely tied to one employer. They were also concerned about losing the area's lucrative position as a leading import and export center for trading partners throughout the Pacific Rim nations. While most goods had been shipped through the port facilities of Seattle and Tacoma on their way to or from destinations across the United States, the advent of jet aircraft meant many of these loads could now easily bypass Seattle completely.

When Rochester floated his plans in 1954 for a new exposition, it was quickly seen as a solution to both the Boeing and the shipping problems. A world's fair could showcase the possibilities Seattle offered to potential trading partners: a large workforce, ample hydroelectric power, undeveloped land for new factories and warehouses, and abundant natural resources. With Al Rochester proudly serving as chairman of the group, a committee was formed to develop plans for the fair and to enlist the necessary state and federal support.

Obtaining state support was relatively easy, as the politicians in the statehouse realized that attracting new business to Seattle would also be good for the state. The state formally agreed to participate in the effort in 1957 and allocated $7.5 million to further develop the plans. Gaining federal approval proved to be a bit trickier, though, as a number of other cities were also exploring the advantages of a world's fair within their own borders. Luckily, the Seattle plans were well developed when an external event had a major impact on the federal decision: the launch of the Soviet Union's *Sputnik* satellite on October 4, 1957. The US government found itself under

a great deal of pressure to respond with a show of scientific prowess, but the exhibit planning was too far along to accomplish this at the upcoming Expo 58 in Brussels. With the support of Pres. Dwight D. Eisenhower, Seattle was chosen as the winner in the competition for the next American world's fair.

With that decision made, it should have been full speed ahead in developing detailed plans for the new fair, but an unexpected wrinkle arose when several other Washington State cities announced their hopes of hosting the fair. Everyone wanted a piece of the economic pie that was sure to result, and intensive lobbying tied things up while the competing proposals were evaluated and ultimately rejected. When the final decision was announced on July 7, 1958, Seattle would still be the home of the fair, and work could finally begin on clearing the site for construction.

By this time, it had become obvious that the fair would not be ready to meet Rochester's original 1959 target, so plans were made to host a two-year event, the Century 21 Exposition, to be held in 1961 and 1962. This led to yet another new obstacle, the Bureau of International Expositions (BIE) in Paris. The BIE, which was formed to control the number and locations of world's fairs, had a firm rule that a fair could only run for a single six-month period. On October 2, 1959, the organizers bowed to the BIE and announced that the fair would only be held in 1962, but formal BIE approval was not received until November 12, 1960. With that, the race was on to sign up international participants, as many of them had been waiting for the BIE decision before they would commit to exhibiting. President Eisenhower agreed to help in the quest by sending invitations to 84 nations. More than 20 eventually agreed to participate, the heaviest concentration coming from the Pacific Rim as the fair committee had long hoped.

After all these delays, many doubted that the fair, which by then had generally been referred to as the 1962 World's Fair instead of the more formal Century 21 Exposition moniker, could actually be completed on time. Some of the major pavilions were not started until fairly close to opening day. Ground-breaking for the monorail system did not start until April 6, 1961, and the Space Needle got an even later start on April 17. There was just over a year to build these futuristic structures, as well as all the other pavilions and facilities. Ford Motor Company started even later, finally deciding to participate on December 5, 1961, just five months before opening.

When the fair finally opened, everything was ready to show the world what Seattle could offer, and the world responded favorably. Exit polls showed an amazing 98.4 percent approval rating, and press coverage was equally enthusiastic.

The fair met all its goals, beating the original attendance estimates and even turning a modest profit. While these numerical achievements are impressive, the fair had a far more long-lasting impact on Seattle. The Space Needle has become a symbol for the city and stands proudly over Seattle Center, the magnificent park built on the former fair site. The economy expanded to include many other companies, which turned out to be an excellent decision given that Boeing is no longer headquartered there. Many of the old fair buildings are still in use today, joined by exciting new museums and other facilities. Al Rochester and all those who joined him in bringing the 1962 World's fair to life could be justifiably proud of the results of their efforts so many years ago.

The 1962 World's Fair was divided into five sections: the World of Science, the World of Century 21, the World of Art, the World of Commerce and Industry, and the World of Entertainment. Each of these sections is explored in detail in this book.

One

SEATTLE WELCOMES THE WORLD

With the site finally set for Seattle and with the blessings of the BIE safely secured, work could begin on designing and building the fanciful world of Century 21. As part of the negotiations among the fair corporation, the city, and the state, it had been agreed that some of the buildings constructed for the fair would be left standing in a permanent post-fair city park planned for the site. It was also agreed that the fair would find a way to incorporate several existing structures, including the National Guard Armory, Civic Auditorium (which became the Seattle Opera House), and the Memorial Stadium, into the fair. Beyond that, the fair officials were pretty much free to do as they cared.

One of the first decisions made was that there would not be one overall design theme as had been done at several past fairs. In order to make the event accessible to some of the less wealthy countries, the fair corporation built several large pavilions that could be subdivided among tenants, but the larger exhibitors were encouraged to create more fanciful and unique designs. The result was a wonderful potpourri of architectural styles, some whimsical and playful, some more traditional, but all intermixed in a colorful collection of shapes and sizes. Where else but at the Seattle World's Fair could one find a building without any straight edges, a house built completely out of plywood, a soaring tower topped by a revolving restaurant, or a massive fountain with water jets synchronized to music?

Taking the fair from design to opening day was far from an easy task. All the governments involved did their best to reduce the red tape (one contractor said it was a wonderful time to be a builder, as the usual permits and inspections were simply bypassed), but there were problems at times with the weather, including heavier than usual snowfalls at the height of construction. The possibility of a labor strike loomed as the unions called strikes at many other facilities, but their leaders eventually agreed that the fair could attract companies that would bring long-term jobs into the area, and the work went on unimpeded. Finally, after four years of design and building, the fair opened as planned on April 21, 1962.

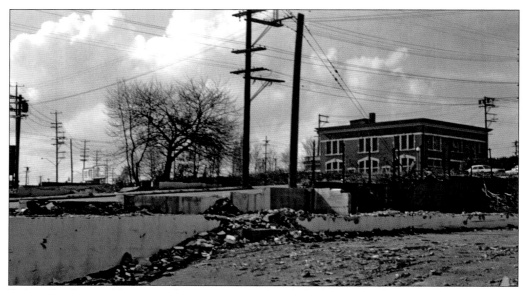

Before the fair could go up, a large section of Seattle had to come down. Although much of the 74-acre site had previously been earmarked for a city park, the land needed to be cleared of numerous old houses and small businesses. Some structures could be used for the fair, such as the armory that would become the Food Circus and a school that became the Press Building, but most were simply razed and hauled away.

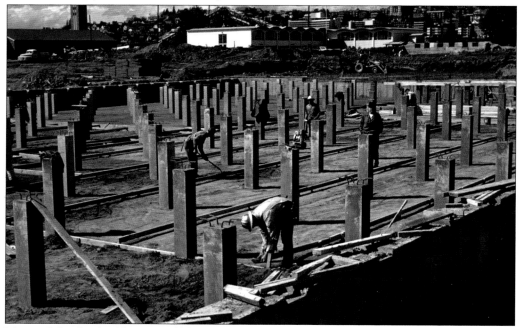

Many of the fair buildings would be taken down when the event ended, so their construction was rather inexpensive and uncomplicated. A number of permanent buildings were included in the plan, and they required a great deal more preparation, including driving piles down to the underlying bedrock. All this work had to be completed before the ground became too hard to work with in the winter.

The unusual design of many of the fair buildings required new materials and construction techniques. Here, a crane is lifting preformed concrete sections into place as the first walls go up for the US Science Center. Angled guy wires were used to hold these first segments in place. The innovative design allowed for wide-open display spaces without the need for interior support pillars.

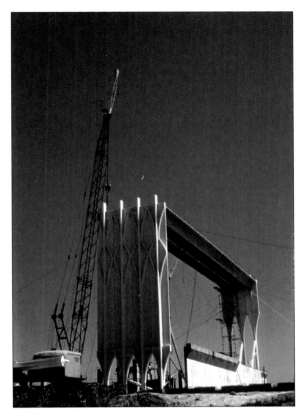

A major milestone occurred on February 18, 1962, when the cars of one of the monorails arrived in town. Built in Europe, they had been brought to the United States by ship and then transported by train from New Jersey to Seattle. The monorail was put on the tracks on February 20, and the first run for VIPs was on March 3. The system opened to the public on March 24.

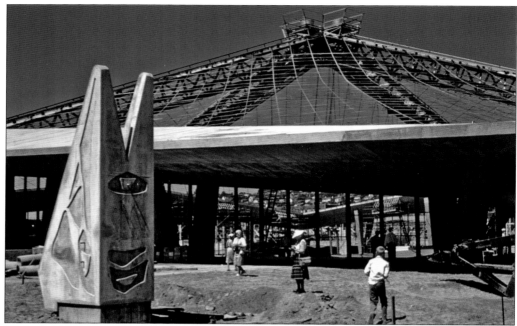

With the fair not yet completed, where did all the early monorail riders go? Surprisingly, the fair site was largely open to the public during the construction phase, so people could stroll through the grounds and watch as it was being built. Such access is nearly impossible to believe today, but back then the fair organizers actually apologized when they had to restrict access during the final three weeks of construction so the fair could be completed on time.

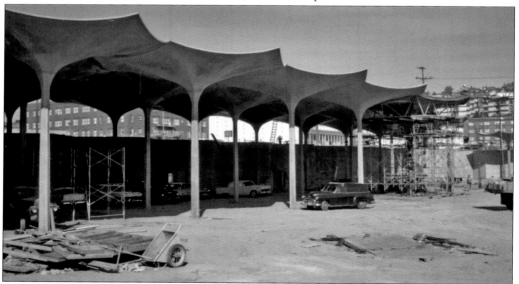

Most of the buildings were unlike anything the visitors had ever seen before. The experience had to be slightly confusing, as it was not easy to determine what exactly they were looking at or how it would look when finished. This large open-air structure, for example, would eventually be closed in and house many of the international exhibits. A variety of different facades would mask the overall uniformity of the building.

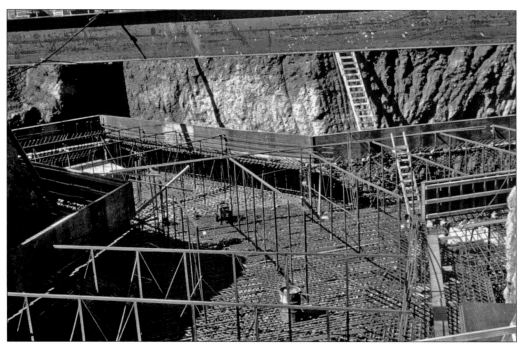

One of the most elaborate construction projects was the massive foundation needed to support the 605-foot-high Space Needle. The towering structure would have to withstand hurricane-force winds, so a 30-foot-deep hole was cut into the bedrock and lined with reinforcing steel bars. Visitors were encouraged to guess how much cement it would take to fill the hole; it is unknown whether anyone guessed the correct answer of 467 truckloads.

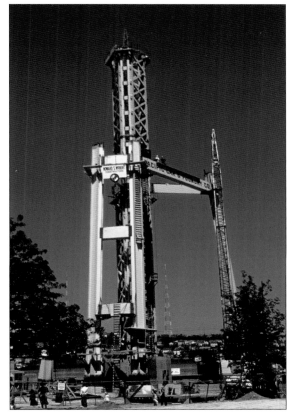

Once the foundation was finished, the Space Needle quickly began to rise. The unusually shaped structure required very specialized skills and tools, and the fair's major contractor, the Howard S. Wright Construction Company, was joined by the Pacific Car & Foundry Company, which fabricated and erected the steel framework. During construction, the steel was covered by yellow primer paint; the soaring legs and central tower were repainted "astronaut white" when the Space Needle was completed.

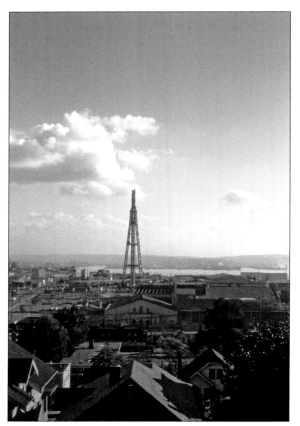

Day by day, the tower reached farther into the sky. Although it was the signature structure at the fair and used in much of the advertising and on many souvenirs, the Space Needle was privately funded and operated under a license from the fair corporation. The $4.5 million cost was recouped by a separate $1 admission fee to reach the top; in fact, the Space Needle was so popular it was reported to have turned a profit well before the fair closed.

Finally, just 400 days after construction began on the Space Needle, it was finished, making it the tallest structure west of the Mississippi River at the time. It is one of the best recognized surviving structures from a world's fair, second only to the Eiffel Tower, which was built for the 1889 World's Fair. The Space Needle remains immensely popular with visitors. Today, more than a million riders each year pay an $18 fee to reach the observation deck at the 520-foot level.

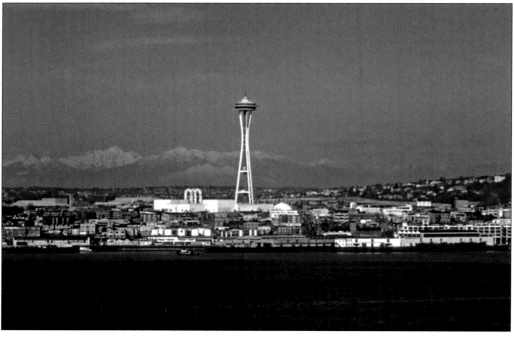

Two

THE WORLD OF SCIENCE

When the US government agreed to support and participate in the fair, it was under the condition that the federal pavilion would have a very strong scientific orientation. This came about in large part due to efforts by a consortium of American scientists who were dismayed by the Russian advances in science that had led to the launch of *Sputnik* in 1957, so they lobbied for an international science fair to increase American interest in science. When the fair organizers traveled to Washington, DC, to gain support for their project, it was suggested that they join forces with the scientists who had developed initial plans for what was now being called the International Exposition of Science. Anxious to win approval for the fair, the Seattle contingent agreed, and a new 18-member National Science Planning Board met in Seattle on August 6–7, 1958, to devise plans and requirements for the federal pavilion.

The result would be an exhibit that was very different from the previous US pavilion at Expo 58 in Brussels. The atmosphere there had been much lighter, focusing on the latest in women's fashions, architecture, and a soft-sell look at the advantages of the American lifestyle. The USSR pavilion had taken a decidedly different approach; it featured the latest in Soviet spacecraft and other technologies. While the US pavilion was an attractive design, the exhibits were generally panned, and all involved in the 1962 pavilion agreed they needed to make corrections for the new fair.

The agreed-upon approach for Seattle would be strictly science based. More than 125 exhibits explored all aspects of science, including several displays showcasing the contributions of scientists from other countries; with the Cold War under way, no Soviets were included.

The US Science Exhibit was given one of the best locations at the fair, a 6.5-acre plot located at the site's highest point. Almost $10 million was spent on the complex of buildings and the science displays. Attracting more than six million visitors (70 percent of all those who came to the fair), the exhibit was extremely successful.

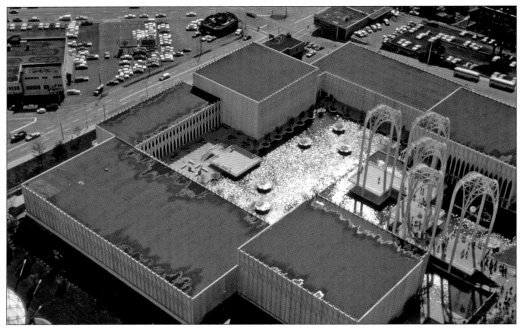

Seen from the Space Needle, the exhibit had six sections that surrounded a large reflecting pool and fountains. Clockwise from the bottom center are the Horizons of Science, the Methods of Science, Junior Laboratory of Science: Doing Science, US-Boeing Spacearium, the Development of Science & Science Theater, and the House of Science.

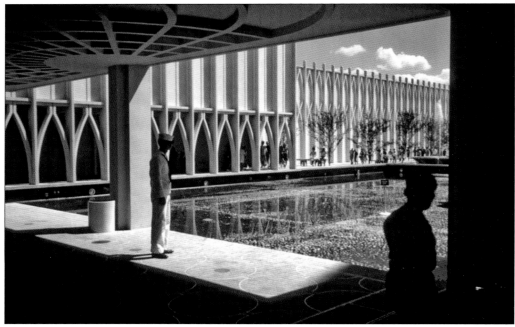

Architects from across the country submitted designs for the pavilion; the honor eventually went to Minoru Yamasaki. Born in Seattle, Yamasaki based his design on a series of narrow Gothic-style arches. He later would use the same motif for the World Trade Center in New York City.

Yamasaki had to incorporate a specific set of requirements set forth by the pavilion design committee. It had studied successful pavilions from past world's fairs and decided to incorporate elements from the Sweden pavilion at the 1939–1940 New York World's Fair, including a series of interconnected buildings, a central reflecting pool, and a large eye-catching tower.

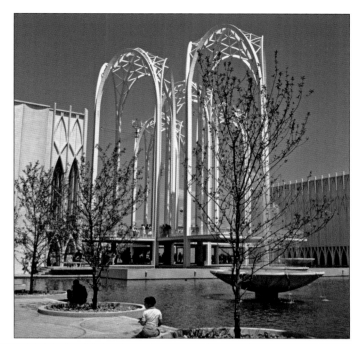

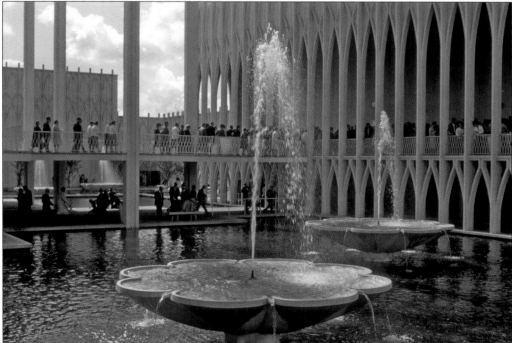

The use of separate buildings rather than one large pavilion was driven in part by the fact that the fair site already had several large existing structures in place and another one planned. An old armory would be used as the fair's major dining facility, Memorial Stadium would be the site of sports events and a circus, and the State of Washington was planning a new coliseum, so the federal team was determined to make its exhibit stand out.

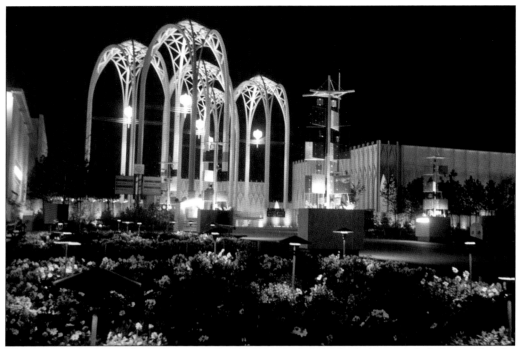

The open-air arches at the entrance to the US Science Exhibit look deceptively light and fragile. In reality, the 100-foot-tall towers each contain a steel framework designed to withstand hurricane-force winds. During the fair, the lacy white spires looked especially beautiful at night when they were lit by a series of floodlights. Today, special lights are used to change the color scheme for holidays and special events.

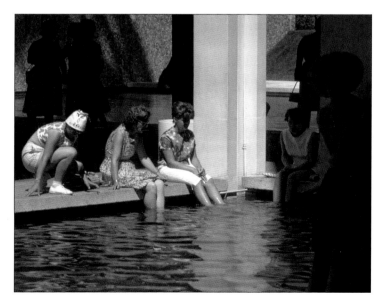

Although it was officially frowned upon, many visitors could not resist soaking their weary feet in the reflecting pool. The summer of 1962 was dryer and warmer than usual, making the water a very attractive temptation indeed. Today, although many of the other fountains in the park are open for wading, these are still off-limits for safety and health reasons.

All visitors entering the pavilion first stopped to watch a 13-minute film titled *The House of Science*. One of the first multiscreen films released, it used seven 35-milimeter projectors linked together to show images on six screens; each screen could show a separate image, or they could be combined for one large view. The film was the work of Charles and Ray Eames, noted architects, interior designers, and filmmakers. The theater did not have seats; audiences were invited to sprawl out on the floor.

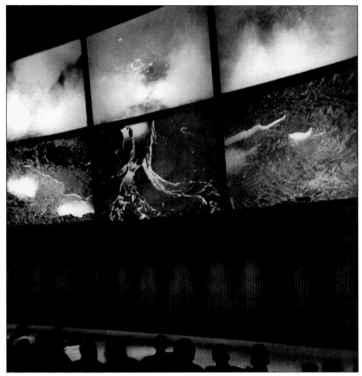

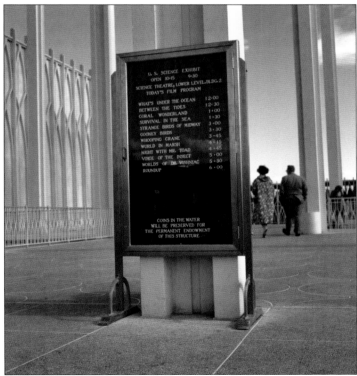

As the schedule sign indicates, many topics were covered in the presentations held at the US Science Exhibit. More than 200 films were rotated through screenings in the theater. The sign also shows that people were fond of throwing coins into the fountains. Although the coins are taken out on a regular basis, an astonishing variety of coins, souvenir pins, and game tokens from the fair were found inside when the drain pipes were cleaned in 2011.

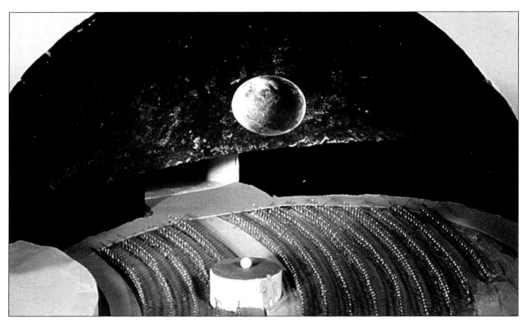

The Boeing Spacearium, seen here as a design model, showed the 13-minute film *Journey to the Stars* on a 78-foot-diameter curved screen—the world's largest. A specially designed lens and high-speed, 70-milimeter projectors were used for what was dubbed "Cinerama 360." Unique electronic music was provided by Attilio Mineo, who also did the theme song for the fair's futuristic Bubbleator elevator. The theater is now used as the Laser Dome at the Pacific Science Center.

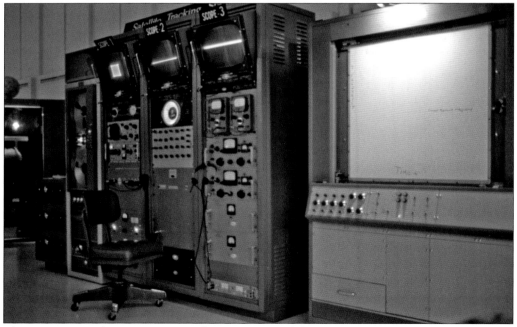

There was tremendous interest in satellites in 1962, and they were heavily featured at both the US Science Exhibit and the NASA pavilion. This equipment was used to communicate with weather satellites and provided fairgoers with a close-up look at this revolutionary new technology.

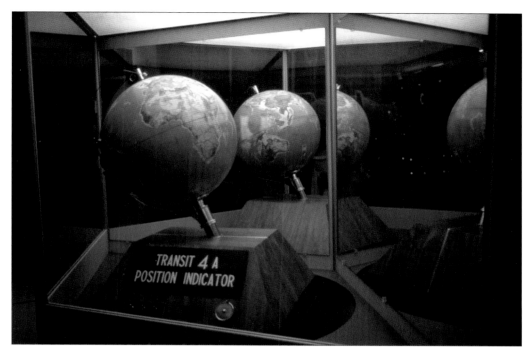

Early satellites did not stay in fixed or geosynchronous orbits, moving instead over points on Earth at various times. This device illustrated how a satellite would come into and out of range of ground stations, making communication satellites unsuitable for anything other than short connections. Another display explained the upcoming benefits of geosynchronous satellites; the first operational one was Syncom II, launched in 1963.

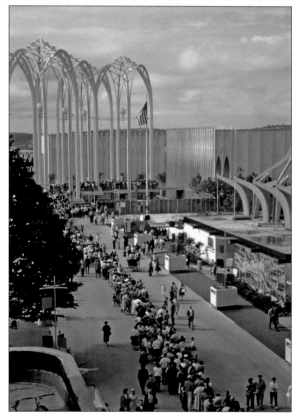

Despite some predictions that the displays might be too dull or too confusing for the average fair visitor, the US Science Exhibit quickly proved to be a success. Press coverage was quite favorable, and long lines such as this were a common sight. It would be interesting to know how many of these guests later followed a career in the sciences due to their time at the fair.

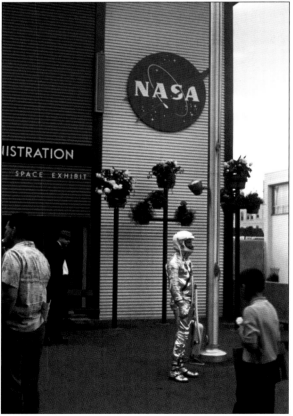

After the fair ended, the complex of buildings and exhibits was initially leased to the City of Seattle for $1 per year. The facility is now operated as the Pacific Science Center, a nonprofit science museum and educational center that is one of the cornerstones of the Seattle Center park built on the former fairgrounds.

NASA, the other exhibitor in the World of Science section, came up with a unique way to draw visitors to its display. One of the staff members dressed in a space suit and wandered around outside the pavilion, inviting passersby to step inside. Luckily, it was a real, functional space suit, as the suitcase-size box he is carrying provided air-conditioning in the summer heat, just as an astronaut would use on his way to the launch pad.

Among the displays inside was a large globe of the Earth showing the orbital tracks of all of the satellites then circling the planet. Considering that the first satellite, *Sputnik*, had been launched just five years earlier, it shows the amazing progress that had been made in space flight. Displays below the globe provided details on the American satellites and their scientific missions. (Courtesy of Albert Fisher.)

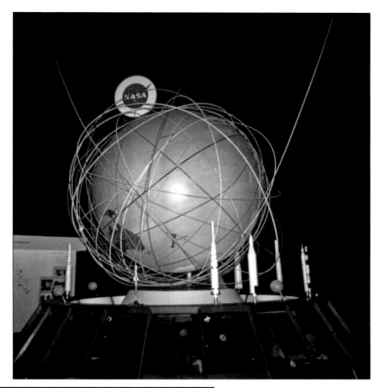

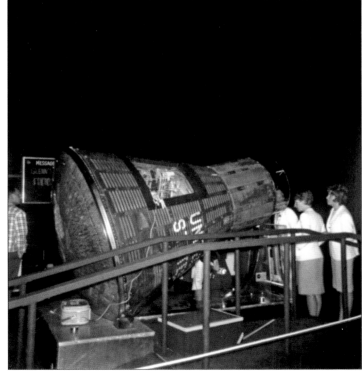

While most of the NASA displays were mock-ups, one very special item was added during the fair. John Glenn's Mercury capsule, *Friendship 7*, was loaned for a display before making its way to the Smithsonian Institution. Long lines formed every day for a look inside the tiny spaceship, giving many visitors a new appreciation of the challenges the astronauts had to face in their conquest of space. (Courtesy of Albert Fisher.)

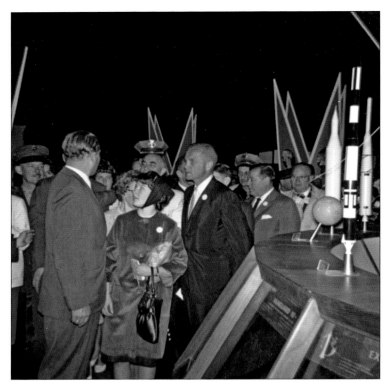

After several Russian cosmonauts visited the fair, a public-relations crisis arose when the press began asking why there were no American astronauts there. NASA responded with a quickly improvised visit by John Glenn on May 10, 1962. Seen here at center looking at Dr. Werner von Braun inside the NASA exhibit, Glenn proved to be one of the most popular visitors to the fair, attracting massive crowds as he took a very brief tour of the site. (Courtesy of Albert Fisher.)

The NASA contingent then moved to the fair's opera house for a press conference. Dr. von Braun is seen here with an unidentified journalist. Among the other speakers on the panel was a relatively unknown test pilot, Neil Armstrong, who just seven years later would become the first man to walk on the moon. (Courtesy of Albert Fisher.)

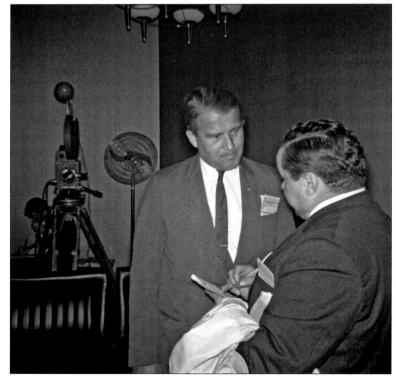

Three

THE WORLD OF CENTURY 21

Even before planning for the world's fair began, many Seattle business and civic leaders had been hoping for years to build a new exhibit and sports center. The city's existing facilities were old and outdated, which made it difficult to attract the lucrative convention business enjoyed by many other municipalities. Plans had been made and announced several times and then sadly discarded once it was realized there was no way to fund them.

Things changed when the fair started gaining momentum. It was inevitable that, as the host of the big event, the State of Washington would have an exhibit of some kind at the fair. The state's first plan was to erect a temporary structure like most of the other fair exhibitors. Some savvy political maneuvers led to a much more ambitious scheme though. The state would build a permanent building, the Washington State Coliseum, which would become a convention center and arena after the fair was over.

The design of the building fell to Paul Thiry, the overall architect for the fair. Asked to design a facility with as much open exhibit space as possible, Thiry developed a unique roof design that covered the site without the need for support poles. Thiry's original design was twice the size of what was eventually built, but even when scaled back for budgetary reasons, the building was quite impressive by any standards. More than five miles of support cables in the roof provided 130,000 square feet of exhibit space. When construction on the massive project was finally complete, Thiry proudly noted that he had delivered it within $100,000 of the initial $4.5 million budget.

After the fair ended, the Coliseum was redeveloped as planned, becoming a permanent part of the new Seattle Center park. Right from the start, it proved to be extremely popular, hosting a wide variety of concerts, including The Beatles in 1964 and 1966 and Elvis Presley in 1970. Many different types of sporting events have been held there, and the arena has been the home to numerous professional sports teams, including the now departed Seattle Sonics basketball franchise. The facility was largely rebuilt and expanded in 1995, at which point it was renamed the KeyArena, the name it still holds today.

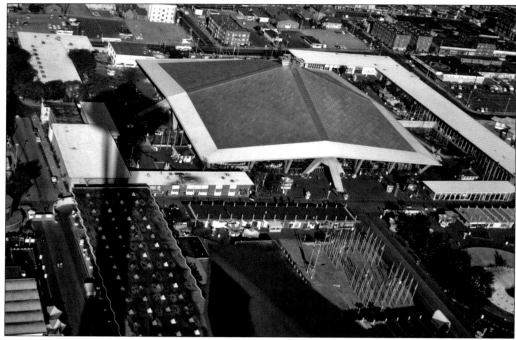

The Coliseum was one of the largest buildings at the fair, making it difficult to photograph properly. One of the best views was from the Space Needle, seen in shadow at left. The State Flag Plaza and parts of the Boulevards of the World and the International Fountain can be seen below the Coliseum.

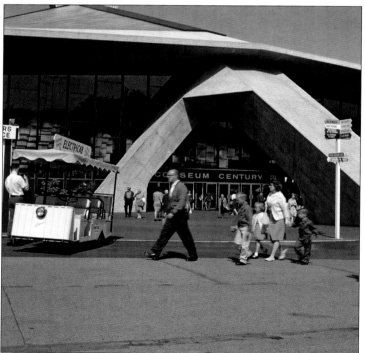

Although the sign over the door proclaims it as "Coliseum Century 21," it was usually referred to as simply the Coliseum. On the left is an Electricab, which, as the name implies, was an electrically powered taxi. Guests could pay 50¢ for a quick ride across the site or, for a higher fee, rent the cart for a guided tour with live commentary from the driver. The cabs were especially popular when heading toward the exits after a long day of walking.

A well-dressed family walks past the Coliseum as the girls enjoy some ice cream. In 1962, it was not at all uncommon for men to be dressed in suits and ties and for women to be in high heels and stylish dresses. As visitors to modern theme parks can attest, the times have certainly changed.

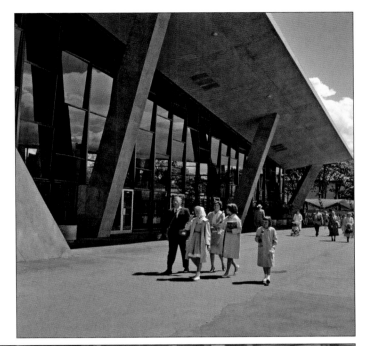

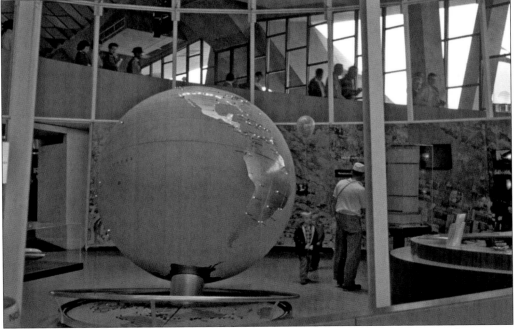

The ground floor of the Coliseum held several industrial exhibits. Although it ceased operation in 1991, Pan American World Airways was the largest American airline at the time of the fair. Its display inside the Coliseum provided a history of the company and showcased its routes across the world. Lights on the globe showed the cities the airline served. Visitors were encouraged to take home information for future trips, or they could book a new reservation on Pan Am right there at the fair.

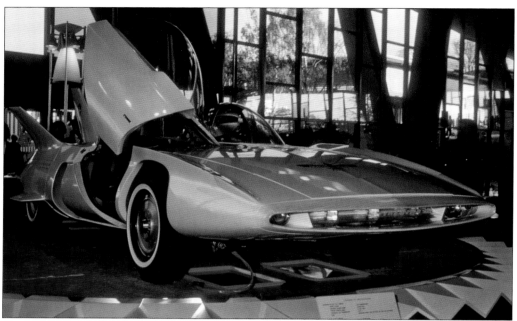

General Motors displayed its futuristic Firebird III concept car. Originally unveiled in 1959, the sleek automobile had a great deal in common with fighter planes, including a titanium body, dual cockpits, sweeping tail fins, and in a very unusual departure from conventional cars, steering controlled by a joystick. It even had air brakes to help in sudden stops. It seems the only feature that actually made it to current cars was keyless door entry.

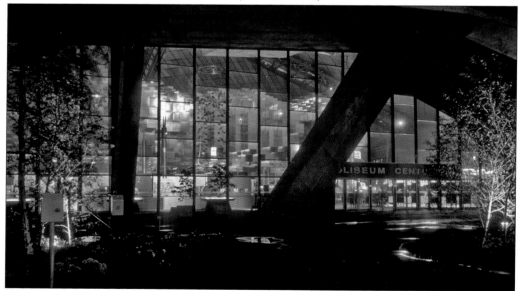

A nighttime view of the Coliseum highlights its illuminated interior, with the France exhibit seen below the silvery cubes of the Word of Century 21 show. France was one of the few European nations to participate in the fair; its 15,200-square-foot exhibit, the largest of the international displays, celebrated some of France's past scientific achievements as well as a look at current advances. The exhibit featured several prominent warnings about mankind becoming too reliant on technology.

Sponsored by the State of Washington, the main show inside the Coliseum was the World of Century 21, which was also known as the World of Tomorrow. Like the France exhibit, it warned of the dangers of letting technology go unchecked. As visitors went through the 21-minute-long exhibit, they were shown how technology could either enrich lives through better living or destroy them through nuclear war.

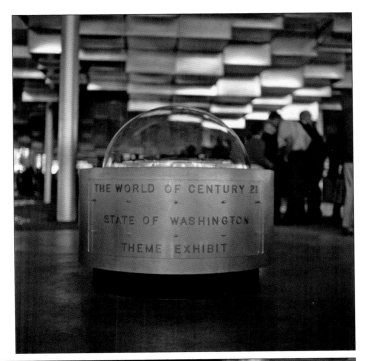

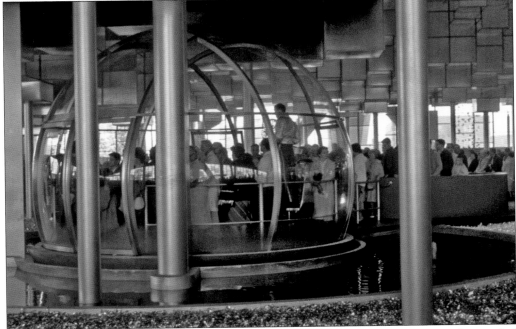

One of the most mentioned memories of the fair was the Bubbleator. A space-age fair needed a space-age elevator, and the Bubbleator, which carried guests between levels of the World of Century 21 exhibit, fit the bill. Guests were entranced as lights flashed and the sound track explained they were being carried far into the future. It may sound silly now, but it was a huge success during the fair.

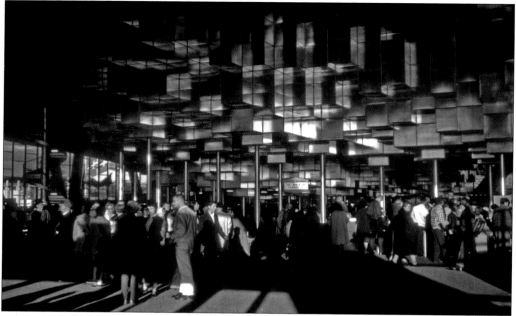

While the Bubbleator was, indeed, a novel way to get visitors inside the show, it could only hold 100 riders at a time, which severely impacted the wait time. As a result, it was not uncommon for long lines to form, but the crowds still loved the Bubbleator. After the fair closed, it was moved to the Food Circus, where it continued to entertain for many years before finally being retired.

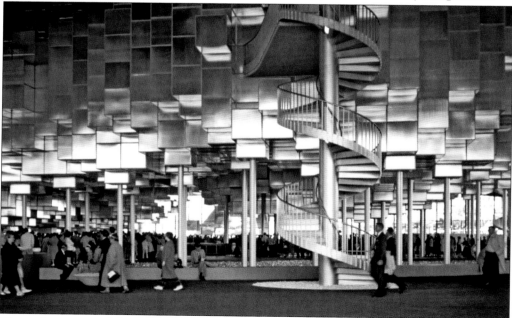

The main portion of the World of Century 21 show was inside this maze of 3,700 silvery cubes, each measuring four feet square. The exhibit was unique in that it was designed so it could be built and then later removed without requiring major changes to the main building itself, thereby making it easier and less expensive to repurpose the structure as a sports arena.

Four

THE WORLD OF
COMMERCE AND INDUSTRY

Of all the many varied sections at the fair, the World of Commerce and Industry was the real reason the whole thing existed. All the rest—the rides, the shows, and even the plans to build a new opera house and other civic improvements—were all secondary to the hopes of attracting new business to the region.

In the years leading up to the fair, the organizers had approached a long list of American companies and international groups, both governmental and industrial, touting the benefits of exhibiting their products in front of the millions of guests that were sure to attend. They were largely successful, thus resulting in a wide-ranging set of exhibits.

The World of Commerce and Industry was divided into two sections, domestic and international, with the exhibits generally located accordingly. The dividing line was not actually clear-cut, though, so some of the international displays were housed apart from the others as the fair organizers worked to find homes for them on the increasingly crowded site.

The majority of the international pavilions were sponsored, at least in part, by the government of their exhibiting country. Some were partnerships with trade associations, and a few were sponsored solely by businesses. In addition to the larger pavilions in this part of the fair, which provided more of a general look at the business opportunities afforded by that country, there were also a number of smaller exhibits with outlets for their retail products. These were located in the Boulevards of the World section, which is described in chapter six.

The fair celebrated the international exhibitors with a series of national days that featured performances by dance teams, musicians, and other entertainers, some composed of expatriates living in the area and others who traveled to the fair from their homelands. This large international component helped mask the more mercenary aspects of the fair, and the emphasis on business has largely been forgotten today by those who visited the fair in 1962.

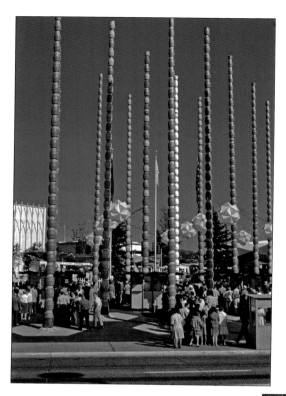

The entrances to the fair were marked by brightly colored poles that soared high into the sky. Styled after totem poles, which were common in the Northwest, the distinctive markers helped visitors find their way to the ticket booths and turnstiles. They also marked the exits for weary fairgoers at the end of the day. This is the south entrance, which led into the commerce and industry areas.

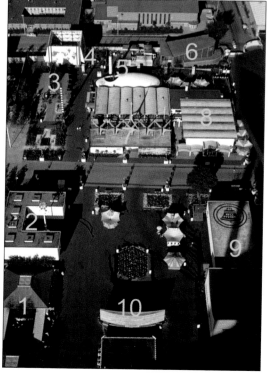

This view from the Space Needle shows how compact the fair site was. In just this one area are (1) IBM, (2) Standard Oil of California, (3) Official Information Center, (4) Seattle National Bank, (5) Nalley's Space Age Theater, (6) House of Tomorrow, (7) Christian Pavilion and Children's Center, (8) Club 21, (9) Bell System, and (10) the Horiuchi Mural.

Safeco Insurance operated the Official Information Center. It was staffed by an all-female crew who could answer questions about the fair, find local accommodations, suggest other tourism opportunities, and perhaps best of all in the days before cell phones, take messages to relay to other guests if they stopped by. Visitors could also sign the fair's official guest book.

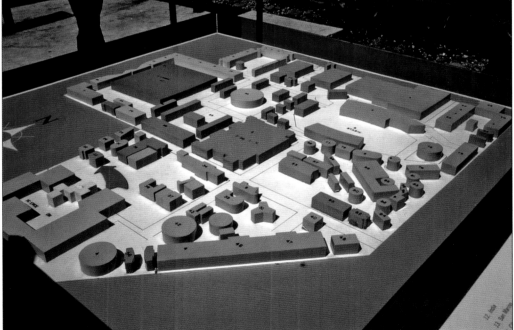

Guests could also use this large wooden model of the fair, which was just outside the main building of the information center, to help plan their day. Exposed to the elements, the model had started to lose some of its labels by the time this photograph was taken in August 1962. Oddly, the information center was located far into the grounds, not near one of the entrances.

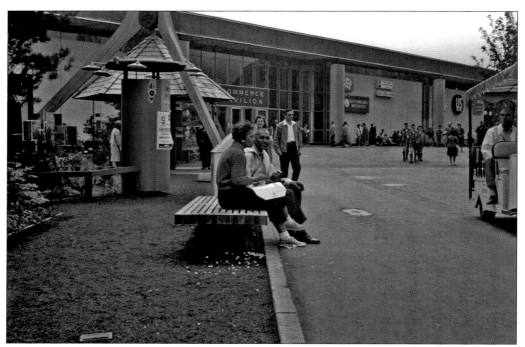

The Hall of Commerce was actually one section of a massive 500-foot-long building that also held the Fashion Pavilion and Interiors Pavilion. Overall, this was probably the most disappointing section of the fair; it featured exhibits about encyclopedias, rubber and sugar production, and a sure-to-thrill display on modern dental techniques. Perhaps the most exciting section was a preview of the 1964–1965 New York World's Fair.

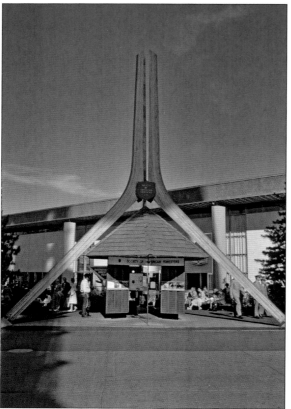

The fair organizers invited many smaller organizations to join in alongside the multimillion-dollar displays from the major exhibitors. This helped those with lower budgets, of course, but it also filled in some empty spots across the site. Just outside the Hall of Commerce, the Society of American Foresters had displays and a short film about the importance of lumber products and the need for forest management. Naturally, the booth was made of wood from area trees.

While the exhibits in the Hall of Commerce focused heavily on industrial commodities and manufacturing, the Hall of Industry was oriented more toward retail products. It almost seems as if the planners had managed to swap the building names in error. A series of colored panels on the south side of the building helped draw more crowds than the bland design of the Hall of Commerce.

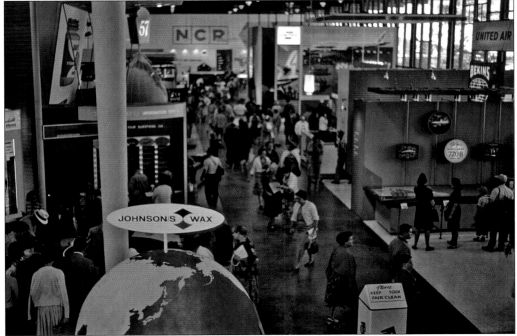

The Hall of Industry held displays from a wide spectrum of companies. The largest exhibitor was National Cash Register, which displayed the latest in calculators, computers, and of course, cash registers. Heinz gave away tiny plastic pickles, which had been popular at the 1939–1940 New York World's Fair, while Johnson's Wax extolled the value of its products on both floors and shoes. With 10 different industries represented, there was supposedly something for everyone.

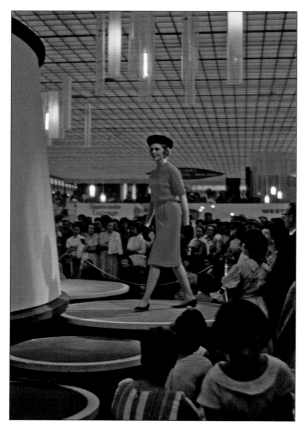

The highlight of the 9,000-square-foot Fashion Pavilion was a fashion show sponsored by *Vogue* magazine. The 20-minute show, held four times each day, featured the latest clothing from 20 manufacturers and displays of hair products from Clairol. The models stepped across a series of discs above a 4,600-gallon fountain that was scented with a different Revlon perfume each month. Guests could order the displayed items for home delivery from local department stores.

The Nalley's Fine Foods pavilion was one of the more unusual structures at the fair. Designed with no straight edges, it featured a series of undulating curves that were intended to soothe the nerves of weary visitors. In addition to displays about the company's products, the pavilion also featured highly successful films about the Pacific Northwest in its Space Age Theater.

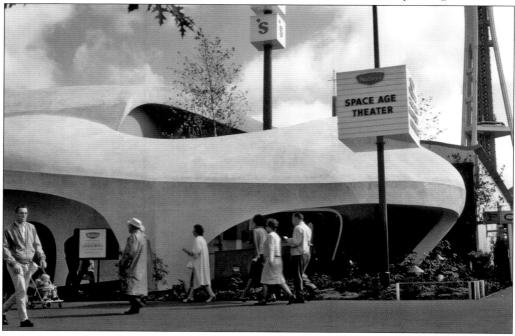

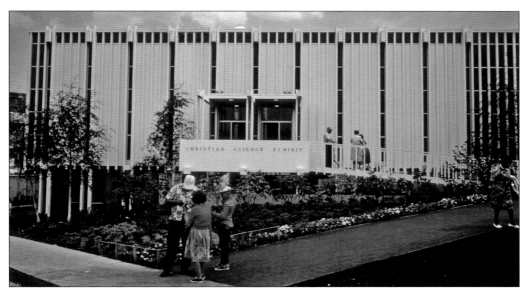

The Christian Science Exhibit was probably the quietest and most relaxing portion of the fair. Guests were invited to sit and read copies of the *Christian Science Monitor* newspaper, listen to taped news reports from its correspondents around the world, or just spend a quiet moment in contemplation. Those interested in learning more about Christian Science could meet with counselors from the Churches of Christ, Scientist, to discuss the religion.

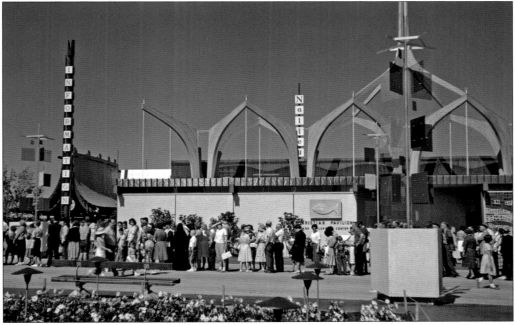

With its soaring wooden arches that invoked images of grand cathedrals, the Christian Pavilion and Children's Center, also known as the Christian Witness Center, was sponsored by more than 30 religious organizations. The center provided adults with a multimedia show about the importance of faith, but it may be best remembered as the fair's day-care center. Parents could drop off their children, ages three to seven, and then enjoy the rest of the fair.

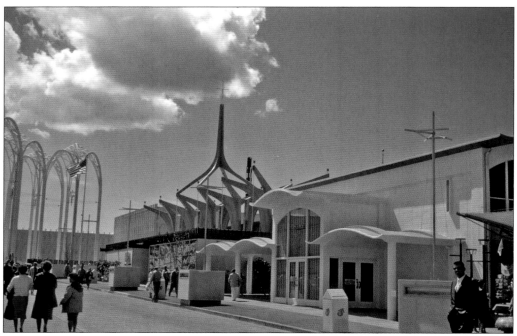

Next door to the Christian Pavilion was Club 21, an exclusive retreat for world's fair executives and members who paid $250 for the privilege. The building posed quite a problem for the fair designers, as it had just been completed as a Shriners temple when the fair was announced. The fair first sought to raze it but was eventually able to lease it for the run of the exposition.

Many local civic organizations held their meetings at Club 21 during the fair. Exhibitors and VIPs could also avail themselves of the club's restaurant, shower facilities, offices, meeting rooms, bar, and even a barbershop. As a sign of the times, it was noted that businessmen's wives were also invited.

Computers were still relatively uncommon in 1962 and were generally locked away from the public. IBM sought to demystify them through a series of displays and exhibits that explained how they operated and predicted their future use in education, business, and possibly even the home.

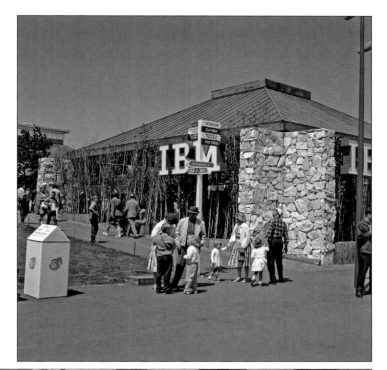

In one of the IBM exhibits, children traveled through a maze designed to test their powers of logical thinking. At each junction, the players had to make a yes-or-no decision, simulating the binary logic employed by computers. Another exhibit offered guests the chance to beat a computer in a game of tic-tac-toe.

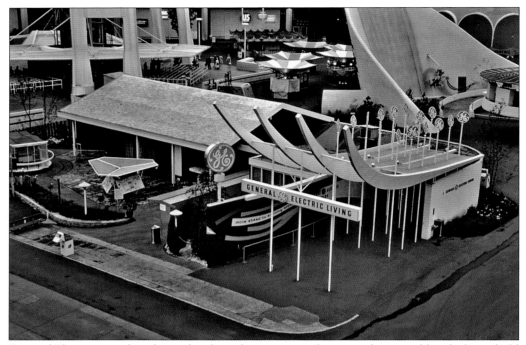

General Electric's pavilion focused on how the company's future products would make household living even more wonderful. While the exhibits might have seen farfetched to some visitors, GE accurately predicted the eventual arrival of large-screen televisions, home computers, and electronic media collections.

It might have looked large and imposing, but the Seattle-First National Bank exhibit was actually a small building topped with large murals that marked its branches and the world's major financial centers. A display of Pacific Northwest sculptures filled the entrance courtyard, and inside was a large collection of vintage coin-operated banks. There was a full-service bank as well, with extended hours to accommodate fair visitors.

It was easy for newcomers to Seattle to find the fair. All they had to do was head toward the Space Needle, by far the tallest structure in the city. The Space Needle was privately financed and operated under a license from the fair corporation, a unique arrangement for a world's fair theme structure.

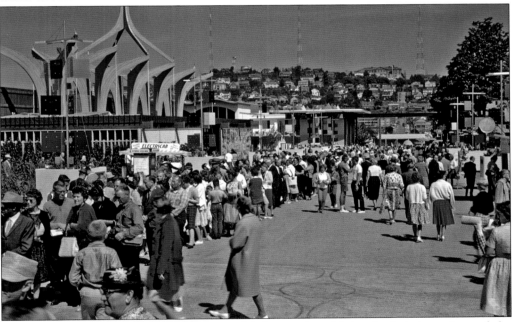

The Space Needle was spectacularly successful despite the additional admission price and the long lines. Eager guests often found themselves waiting in lines that stretched almost the width of the fair site. Part of the problem was that too many people wanted to go up to the top—and once there, they did not want to come back down. The breathtaking views of Seattle were a hit with tourists and residents alike.

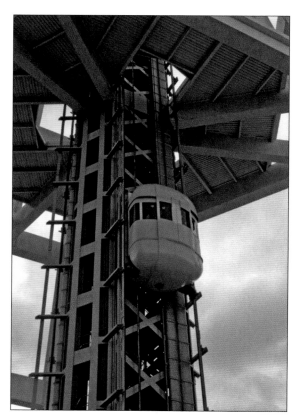

Many visitors to the Space Needle needed some extra encouragement to actually make the trip up to the top. Elevators on the outside of a building were something quite new, and the 43-second ride to the top was quite an experience, indeed. It was still less of a strain, though, than tackling the 848 steps. There are three elevators; one is slower and generally only used for freight and VIPs.

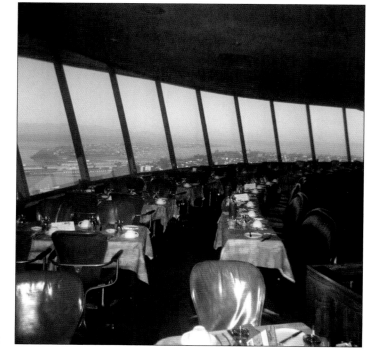

Once safely upstairs, those without a nervous stomach could eat at the Space Needle Restaurant. Hostesses dressed in gold-lamé uniforms escorted diners to their tables, which were situated on a slowly moving platform that made a full revolution every 47 minutes. While there were complaints that the food was expensive, most agreed the magnificent views made the experience worthwhile. (Courtesy of Albert Fisher.)

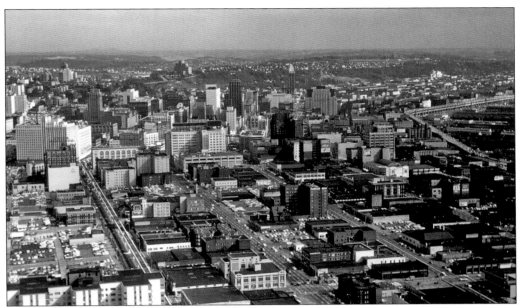

An expansive exterior observation deck afforded views to those who chose not to dine inside. During the fair, there was only a shoulder-height glass barrier at the edge, making it easy to take photographs of the surrounding area. Visitors today need to peer through a much more substantial barrier to see a downtown Seattle that has changed dramatically since this view from 1962.

Although mostly forgotten today, during the fair the Space Needle was home to the 538-bell Schulmerich Carillon, which was billed as the world's largest at the time. Performers played the instrument from a console at the tower base, with the bells amplified and broadcast over 44 loudspeakers mounted at the 200-foot level. Guest musicians were invited to perform, and an automated system could operate the instrument as well.

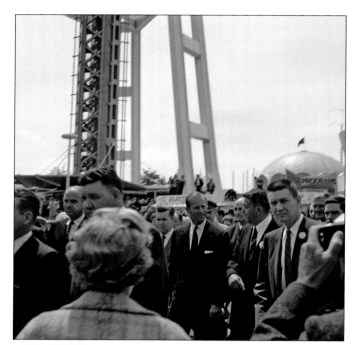

The Space Needle was a favorite stop for visiting celebrities, including Prince Philip of England (center), seen on June 1, 1962. Just to the right of the prince is Joe Gandy, president of the fair. The prince ruffled a few feathers when he was heard disparaging the Space Needle's color scheme by saying the bright orange top looked like protective paint used on bridges.

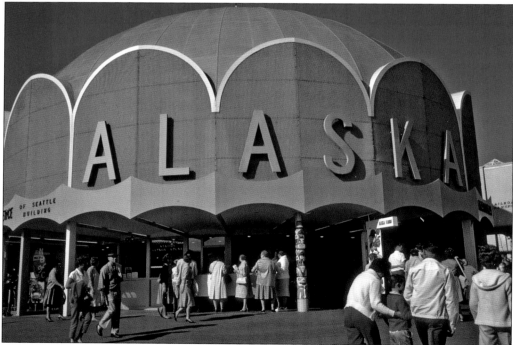

Alaska had just become a state in 1959 and saw the fair as an opportunity to attract new businesses and tourists. Displays inside the igloo-style pavilion showcased the natural wonders of the state; the highlight was a recreation of the Northern Lights on a large screen at the top of the 44-foot-high dome. Underneath was a large relief map that featured many of the state's cities and wildlife areas.

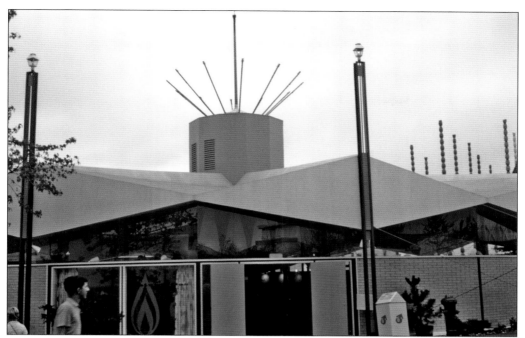

Torches of jetting flames were prominently featured on the roof of the Gas Industries Pavilion. Arranged like the numbers on a clock, each torch would ignite with an earsplitting crack, drawing attention, as planned, to the building. There was also a large gas torch on top of the Space Needle. Such displays would be unheard of in today's more energy-conscious world.

The displays inside extolled the wonders of natural gas for heating and cooling. The history of natural gas was explained, along with predictions on how it would change life for the better in the far-off year 2001. Some of the displays were oriented towards children, but there were also several pieces of gas distribution systems. It was never a very crowded exhibit.

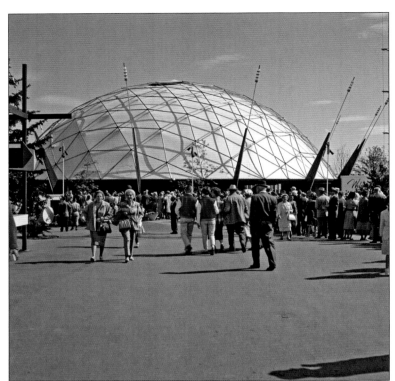

Ford Motor Company invited visitors to *An Adventure in Outer Space*, a simulated 15-minute ride that explored the solar system. The exhibit was extremely popular and had some of the longest lines at the fair. While geodesic domes are more common today, they were quite unusual in 1962. The Ford pavilion appears to mark the first use of such a dome at a world's fair.

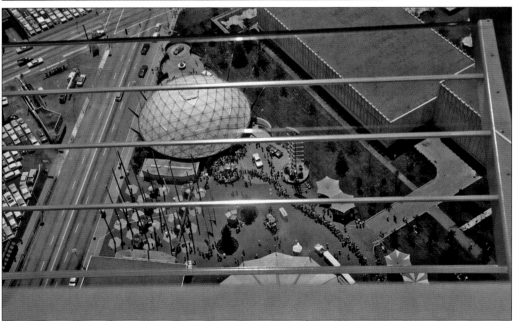

Ford was the last major exhibitor to sign up for the fair, and space was almost gone. Looking through the safety barrier, this view from the Space Needle shows how the pavilion was squeezed into the lawn of the US Science Exhibit, next to the south entrance gates. Signing its contract on December 5, 1961, Ford only had 137 days to design and build the exhibit.

A brightly colored rotating oil molecule towered over the Standard Oil of California pavilion. Displays inside showed how petroleum was used for more than just gasoline, with an emphasis on the many wonders of modern plastics. The building itself was constructed of plastic panels that were treated to adjust the amount of sunlight passing through based on how bright it was outside. One of the fair's popular souvenir stands is seen in front of the building.

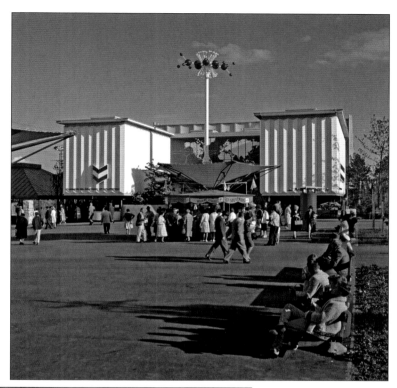

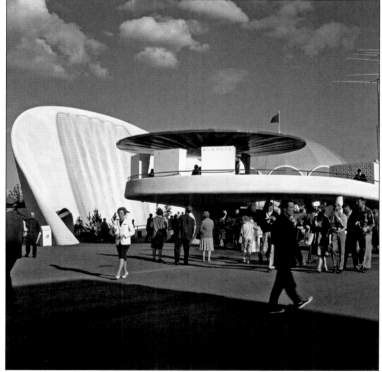

The Pavilion of Electric Power promoted the state's abundant hydroelectric capacity. A steady stream of water cascaded down the 40-foot-high rear wall, which also featured a model of a power plant. In front of it stretched a large relief map showing the major generating and transmission facilities across the state.

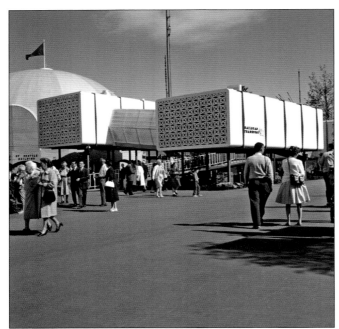

Railroads had always been a part of previous world's fairs, and the tradition continued with the Transport 21 pavilion, which predicted that future trains would run at high speeds atop a cushion of air instead of conventional steel rails. It also predicted riders would be traveling in individually dispatched capsules rather than in large train cars. Both of these elaborate schemes have yet to develop, but they sound much like Elon Musk's Hyperloop system now under discussion.

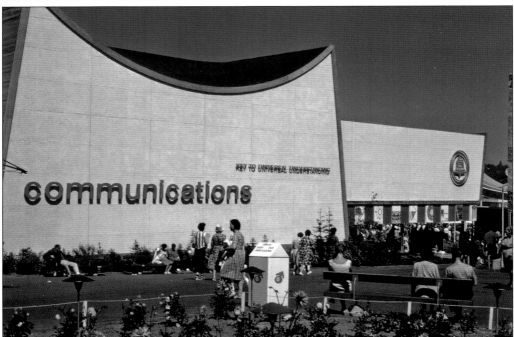

The Bell System was eager to demonstrate that its vast network could be used for more than just calling friends and family across the country. A wide spectrum of business-oriented services was displayed, with an emphasis on connecting companies and computers together for high-speed data transmission. The pavilion also included the first public demonstrations of an amazing new technology: push-button telephones. Guests were encouraged to see how much faster they were than rotary-dial models.

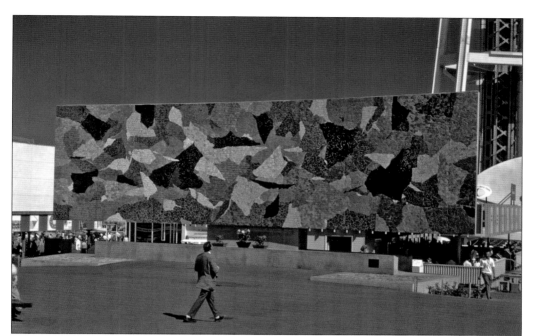

Billed as the largest piece of art in the Pacific Northwest, the Horiuchi Mural was commissioned by the fair as a permanent gift to the city of Seattle. Millions of tiny glass fragments were placed atop 54 concrete panels that stretch 60 feet across and stand 17 feet high. Still in the park today, the mural serves as the backdrop for an outdoor theater area.

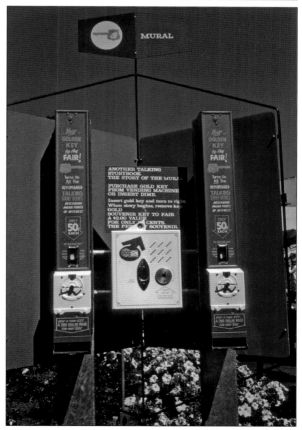

The Talking Storybook system offered prerecorded explanations of major attractions across the fairgrounds. Users could purchase plastic keys that allowed them to operate all the units for only 50¢. This particular unit described the design and manufacturing of the Horiuchi Mural. Similar systems were also used at zoos across the country.

The fair organizers were justifiably proud of the BIE's endorsement of their event, and they responded with a salute to the BIE at the entrance to the international section of the World of Commerce and Industry. One of the panels listed past fairs and ended with an entry for the next scheduled fair, a never-realized exposition planned for 1963 in Hamburg, West Germany.

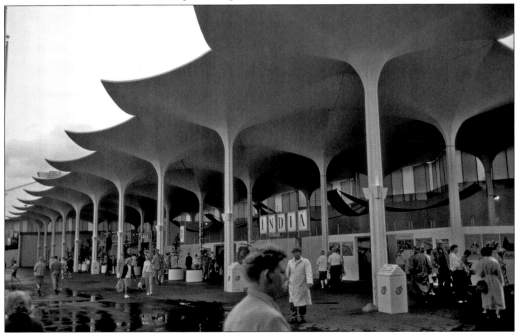

Part of the BIE rules require that space be available rent-free for international exhibitors, with the intent that even the smallest and poorest of nations could participate. Seattle accommodated this requirement with structures such as this one that housed a long row of international exhibits. It was basically an elaborate-looking roof and rear wall under which individual exhibits were arranged.

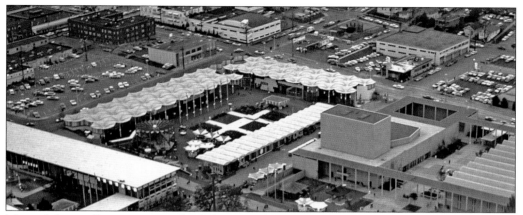

Most of the smaller international exhibits were located in these buildings arranged around the International Mall. The taller building at right was the Playhouse, and the red circular structure was one end of the Union 76 Skyride. BIE rules also allowed for countries to erect more elaborate pavilions if they wanted to shoulder the extra costs, and many did so in other parts of the site.

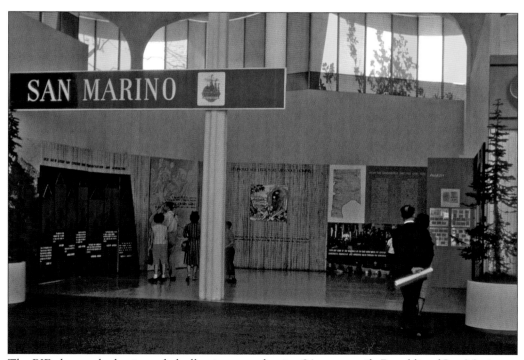

The BIE plan worked as intended, allowing even the tiny 24-square-mile Republic of San Marino to participate. Displays provided information on how the republic was founded and governed, and one section was devoted to the country's postage stamps, one of its principal sources of revenue.

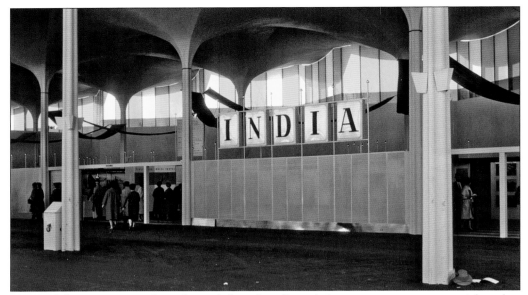

Many of the international pavilions definitely reflected their temporary nature, with rather bland exteriors. The exhibit space did not reach all the way to the tentlike concrete roof. As a result, there was no heating or air-conditioning, but they were set far enough back that rain was generally not an issue.

India featured displays of the economic progress the country had made since the end of British rule in 1947, with traditional products like tea and wooden handicrafts displayed alongside examples of modern offerings from the country's new factories. A wide selection of tourism information was available to those contemplating a visit.

Although the shared buildings were not particularly exciting in their design, they served their intended purpose well. The individual exhibitors often went to great lengths to brighten up their allotted spaces. This photograph from inside the Thailand exhibit shows how colorful and attractive these small rooms could become.

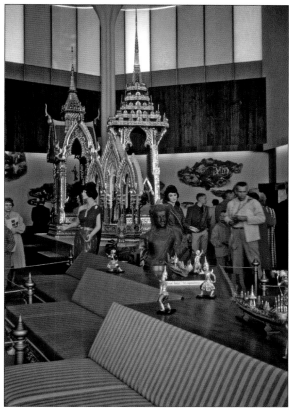

The fair very much reflected the Cold War mentality of the time. There was no pavilion for North Korea, for example, just one for the southern Republic of Korea. Mainland China was also absent, as were all the other Communist Bloc nations. However, with 24 nations participating, some with multiple displays, the international component was judged to be a success.

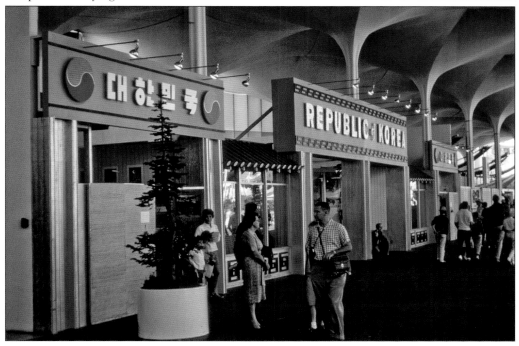

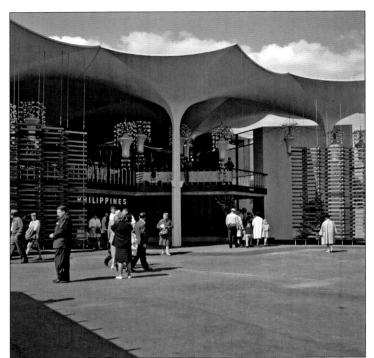

Reflecting its importance as a major Pacific Rim trading partner, the Philippines had a significant presence at the fair. In addition to a large exhibit sponsored by the government fronting the International Mall, there were also two pavilions in the Boulevards of the World section that were built by commercial organizations anxious to showcase their products.

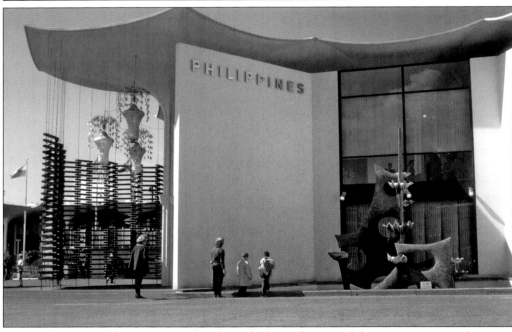

The Philippines exhibit was unusual in that it had two floors, with businessmen invited upstairs to learn more about the natural resources the Philippines could offer. Wood and other materials from the Philippines were used to decorate the pavilion. Even the fountain at the end of the building had a native touch; it used large seashells from the surrounding seas to capture water as it cascaded downward.

Many African nations had recently won their independence from colonial rule, and 28 of them banded together for a shared exhibit that showcased their potential as business partners. The region's poverty was duly noted, with an emphasis on how their citizens were looking to build more stable economies and thus would welcome foreign investors. There were also displays on tourism and African art and handicrafts.

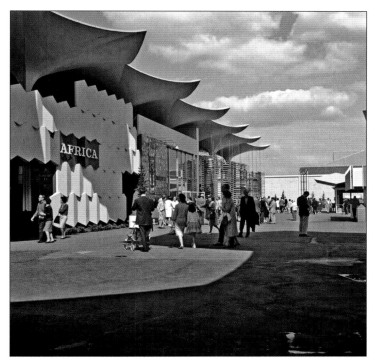

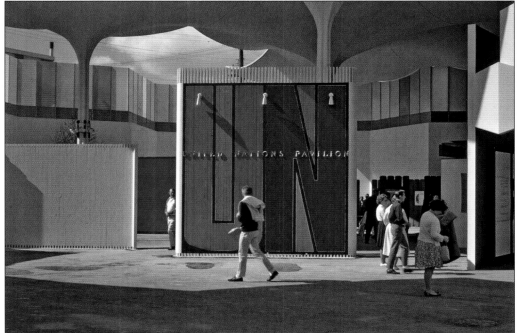

Just next door, the United Nations showed *Tomorrow Begins Today*, a 14-minute film explaining how the United Nations helped war refugees and others in need of assistance due to other widespread problems, such as drought and famine. Information on the founding of the United Nations and its charter were on display, along with literature on many of its programs.

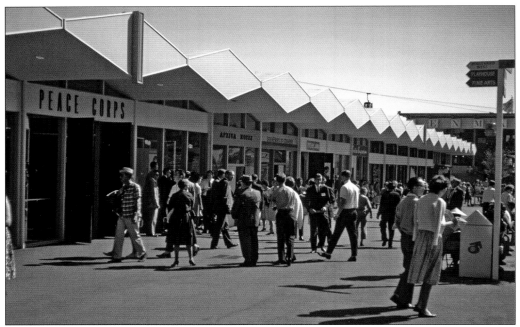

The Peace Corps marked its one-year anniversary with a display at the fair. If guests were suitably impressed with the displays of past and future projects, they could begin the process of enlisting. Information on how to join was also provided for those interested in doing so at a later date. The exhibit was in another temporary building, which also contained a number of souvenir shops that offered products from around the world.

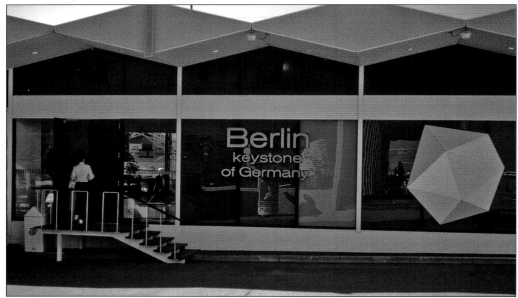

The infamous Berlin Wall was less than a year old when the fair opened, and the western portion of the divided city hoped to show that it was a still a thriving entity and open for business. A large photo mural and other displays showcased the city's rebirth following the war and contrasted the differences in wealth and culture between the western and Soviet-controlled sectors.

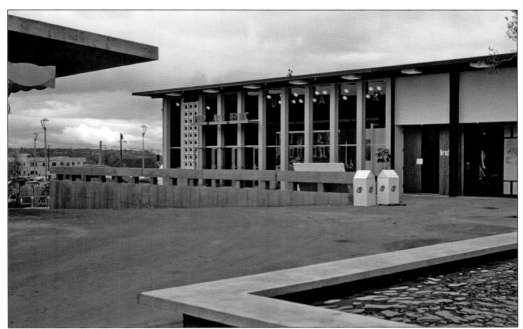

Not all the international exhibits were housed in temporary buildings. Some, like the United Arab Republic, were located in structures designed for reuse after the fair. The UAR had dissolved between the time a contract was signed and the fair opened, but former member Egypt filled the spot with displays on its economy and tourism. The building is still in use at the Seattle Center as the Northwest Rooms.

Drawing large crowds from across the border, Canada was an important participant. The Canada pavilion promoted the diversity of the business opportunities it afforded American partners, from its ample natural resources to the latest developments in missile technology. The DuPen Fountain in front was said to represent the evolution of life from amoebas to manned space travel; it remains in Seattle Center today.

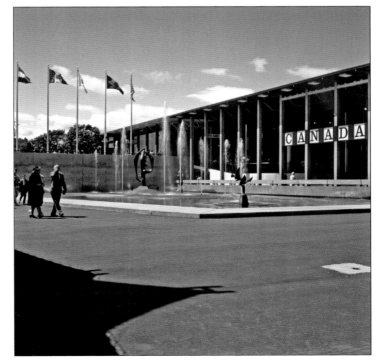

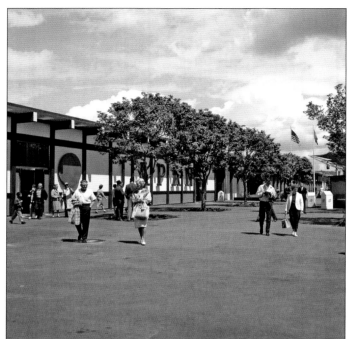

In the years since the end of World War II, Japan had developed a reputation of producing poorly made knockoffs of American and European products. Anxious to correct this, the Japanese government and several prominent businesses joined forces for exhibits on the country's modern factories and cutting-edge technology. Another section of the building focused on Japanese customs and tourism.

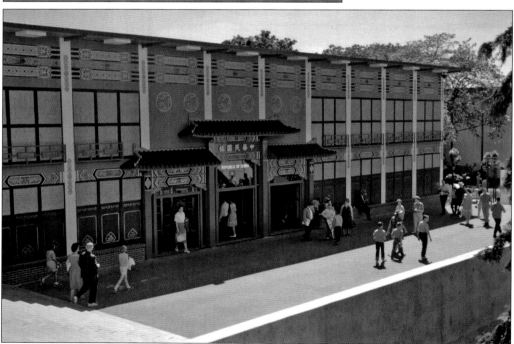

The Republic of China, also known as Taiwan, was also interested in shedding its image as a nation of impoverished peasants. While the exterior might have looked like a traditional Chinese building, the displays inside proclaimed that Taiwan was a modern nation that was bringing new techniques to even its oldest industries, such as farming. An emphasis was put on the many new factories built since World War II and the inexpensive labor force available.

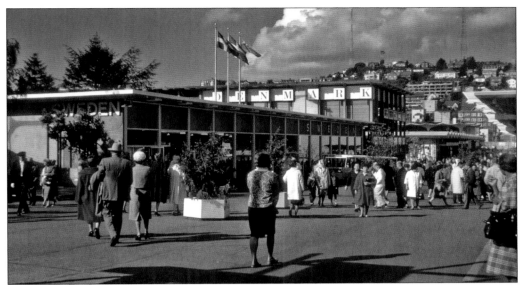

While the fair had been developed in large part to increase trade with the Pacific Rim, a number of European countries did not want to be left out. Sweden and Denmark, seen in the rear, had examples of the latest Scandinavian furniture, clothing, and other household items. Most of the items were available for purchase, including glassware manufactured at the fair.

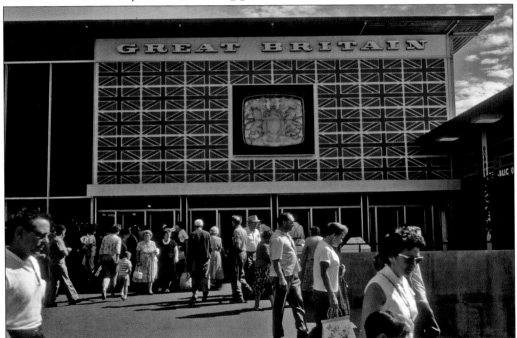

Great Britain celebrated both its past and its future. The past was represented in a salute to Queen Elizabeth II, then in her 10th year on the throne, with a look at how much the country had changed since the rule of her namesake predecessor. The future was highlighted with displays of the latest in British inventions, including the automobile and aerospace industries, with models and depictions of new products still on the drawing boards.

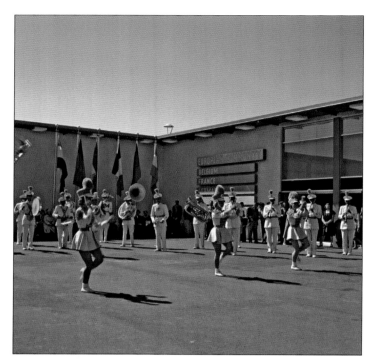

The Seattle World's Fair Band entertains the crowd outside the pavilion of the European Economic Community (EEC). The EEC was relatively new, having been formed in 1958, and the six member nations were there to share their vision of increased prosperity through lower tariffs and the elimination of other traditional trade barriers. Although there was talk of a shared currency, the Euro would not be implemented until 1995.

While almost all of the exhibits in the World of Commerce and Industry focused purely on increasing trade and tourism, there was one attraction that offered some fun and relaxation. The International Mall marked one end of the Union 76 Skyride, an aerial gondola system that linked the area to the Gayway amusement area at the other side of the fair.

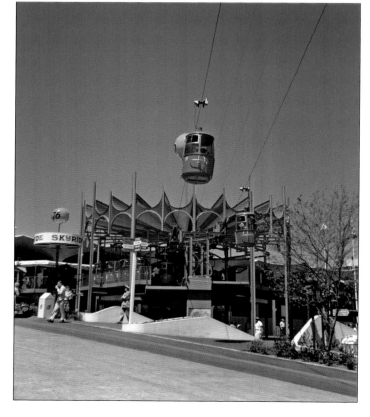

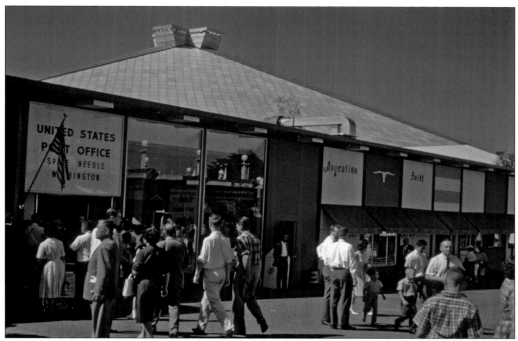

The fair's post office was located here as well. It was a popular stop for many visitors, not just to mail postcards to the folks back at home but also to buy postage stamps featuring the Space Needle and monorail. Many stamp collectors were anxious to have their letters postmarked with "Space Needle, Washington," the special cancellation available only during the fair.

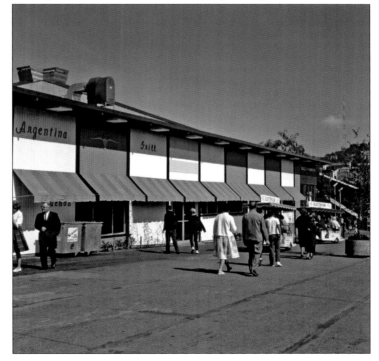

While it had long been the tradition for the international section of the fair to host a wide variety of upscale restaurants featuring the cuisines of the exhibiting nations, the Seattle organizers instead decided to focus the dining elements of the fair in the Food Circus section, which is described in chapter six. There were some food carts in the area, as well as a small Korean food stand, but the only real restaurant was the rather sorry-looking Argentina Grill.

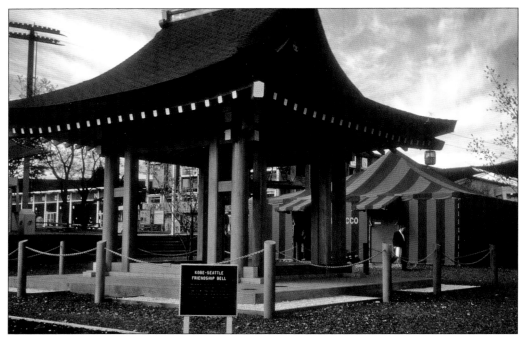

Although it was one of the simplest structures at the fair, the Kobe-Seattle Friendship Bell was remarkable in that it was one of the few elements not finished by opening day. Built in Japan, the pagoda was transported to the fair site and erected by Japanese craftsman who had traveled there just for the project. Now known as the Friendship Bell, it remains in place today.

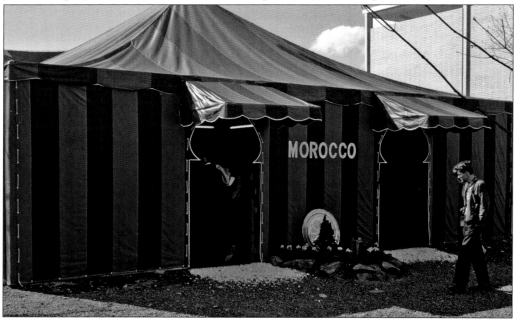

Even simpler was the exhibit from Morocco. Styled after the country's traditional tea tents, it housed a shop offering Moroccan products. A late addition to the fair, the exhibit was so small it was not even listed in the official guidebook or souvenir program.

Five

THE WORLD OF ART AND ENTERTAINMENT

Like all world's fairs, the Seattle fair faced a series of hurdles, not the least of which was funding. The temporary nature of these events makes it difficult to raise the monies necessary to acquire the land, build the required infrastructure, and construct the pavilions, only to tear everything down and leave an empty plot of land behind when the fair is over.

Some fairs mitigate this issue by including a number of structures for later reuse, and such was the case here. Civic leaders had long been looking to build an auditorium to host live musical performances, stage plays, and other artistic avenues. The main venue available during the 1950s was the Seattle Civic Auditorium, a cavernous structure built in 1928 that was infamous for its terrible acoustics. The Seattle Center Advisory Committee was formed to help find a replacement, and in one of those happy coincidences that happens from time to time, its goals aligned perfectly with those of the world's fair organizers.

The advisory committee agreed that the site selected for the fair would be an ideal location for a post-fair arts complex. It happened to house the much despised Civic Auditorium, creating a perfect opportunity to replace it. The residents of Seattle agreed, and on November 6, 1956, they voted to fund a $7.5 million bond to acquire 28 acres of land and to build a 3,500-seat concert hall, an 800-seat theater, and a new multipurpose auditorium.

The results were spectacular. The old Civic Auditorium was completely gutted to become the city's new opera house, a venue so striking that some refused to believe it could be the same building. A steady stream of shows was presented in the new arts complex during the fair, including an impressive art exhibition that drew more than one million paying guests.

Some world's fairs have been derided for their lack of culture and style, but the 1962 fair received high marks for its contribution to the region's performing arts community. In the years since, many of these venues have been remodeled and expanded, but they all owe their existence to the fair.

A rather stark design made it possible to build the 800-seat Playhouse in an amazingly short 34 days. A variety of performances were held there during the fair, along with press conferences and other official fair events. The building, now named the Intiman Theater, is part of the arts complex at the Seattle Center.

Guests entering at the north entrance, also known as the Presidential Gate, were greeted by signs showcasing the art exhibits inside the Fine Arts Building. The exhibits were a source of pride for the Seattle art community, and the printed catalogs of the displays remain valuable reference items today. This view was taken on opening day; tire tracks from work trucks and missing directional arrows show how tight the construction schedule was.

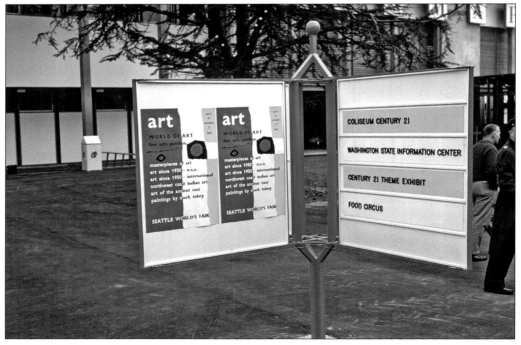

Former Vice President Richard M. Nixon (center) was one of the many celebrities who visited the fair. He is seen here in the appropriately named Presidential Court between the Playhouse and the Fine Arts Building. He is escorted by Joseph Gandy (left), president of the fair, and Bill Borah (right), assistant director of the fair's Special Events Division. (Courtesy of Albert Fisher.)

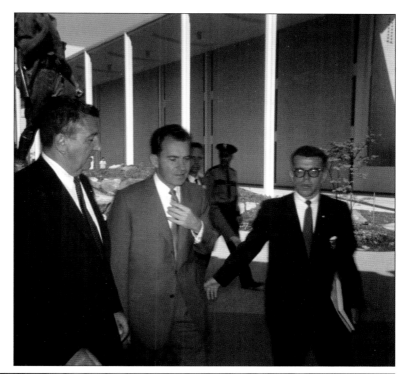

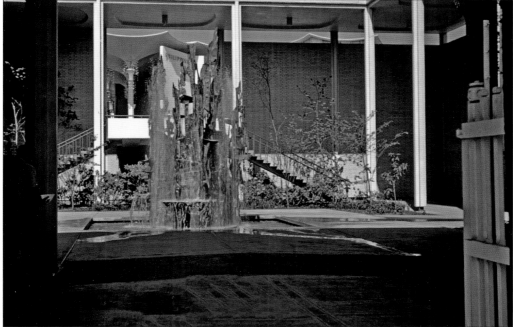

The small site of the fair did not lend itself to large outdoor sculptures. A notable exception was the *Fountain of the Northwest* by James FitzGerald. Located in the courtyard of the Fine Arts Building, the bronze fountain is still there today, but the water flow appears less impressive than during the fair.

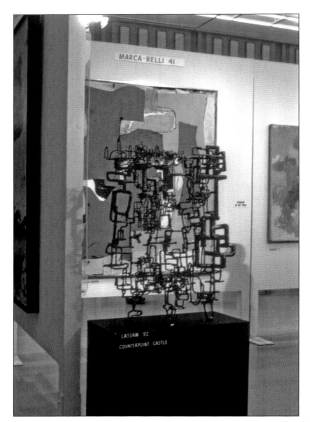

The exhibits inside the Fine Arts Building ran the gamut from works by the Old Masters to contemporary art. Some pieces were loaned by local museums, and others came from private collectors and the artists themselves. Exhibiting at the fair was welcome exposure for the artists, and the art committee had to turn away many offers. This is *Counterpoint Castle*, a 1957 sculpture by Ibram Lassaw, who was noted for his work in abstract art.

When the opera house reopened for the fair, past visitors were stunned by the new interior. The much-maligned building had been turned into a world-class facility that was praised for its acoustics. True to its name, the building actually did host several operas during the fair, and many of the celebrities who came to the fair taped segments of their television programs there. Other musical and stage acts performed there as well.

Singing cowboy Roy Rogers and his wife chose the fair for the first segment of their new television series, *The Roy Rogers and Dale Evans Show.* They were joined by longtime costars the Sons of the Pioneers and Pat Brady, with Cliff Arquette there in his character of "Charley Weaver." Albert Fisher, who served as Rogers's liaison to the fair, recalled that Rogers and Evans were very approachable and glad to meet their fans during breaks in the taping.

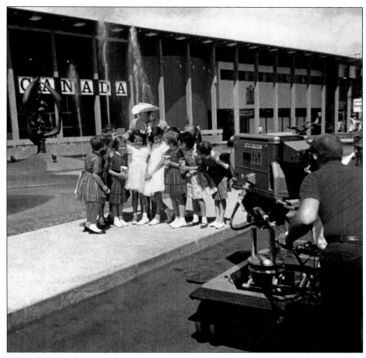

Other celebrities joined millions of fellow visitors and came to the fair as tourists. As might be expected, they usually attracted a great deal of attention. Some held press conferences, and others just tried to blend in with the crowds. From the looks of her outfit, Carol Channing probably did not blend in well. She was in town sharing the stage with George Burns at the Orpheum Theater when she took a day off in June 1962 to see the fair.

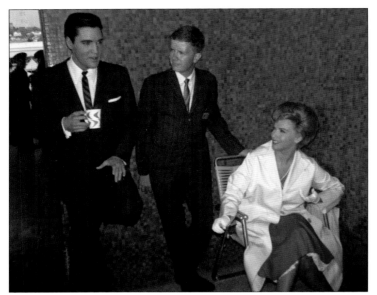

The biggest star to come to the fair was Elvis Presley, who was there to film his 1963 hit film *It Happened at the World's Fair*. Elvis's popularity posed some interesting challenges during his sequences as adoring fans tried to get close to their idol. Taking a break away from the crowds, Elvis is seen at the base of the Space Needle with Albert Fisher, the liaison between the filmmakers and the fair, and costar Joan O'Brien. (Courtesy of Albert Fisher.)

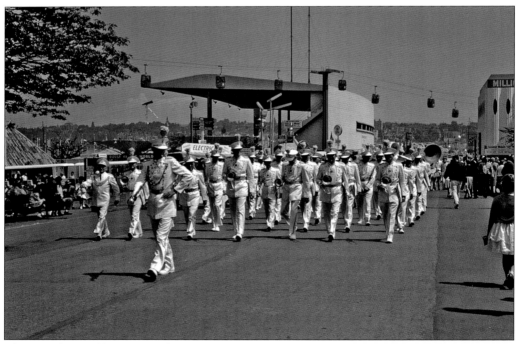

The Seattle World's Fair Band entertained visitors as it marched across the fair site playing a variety of classic songs, as well as several composed specially for the fair. A picture of a giant atom adorned their uniforms, with the fair logo as its nucleus and music notes as electrons. The band was led by Jackie Souders (far left), a well-known local musician and bandleader who often performed at area hotels and events.

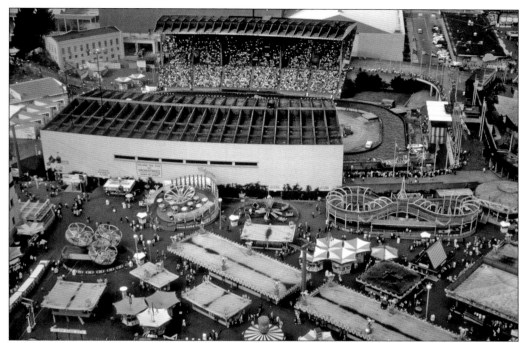

A large part of the World of Entertainment was filled by Memorial Stadium. Built in 1947, the 12,000-seat structure often proved hard to fill, but it looks like it had a busy day in this shot from the Space Needle. Owned by the school district and leased by the fair, the stadium is still there today. The Gayway amusement area, seen at the bottom of the photograph, is described in chapter seven.

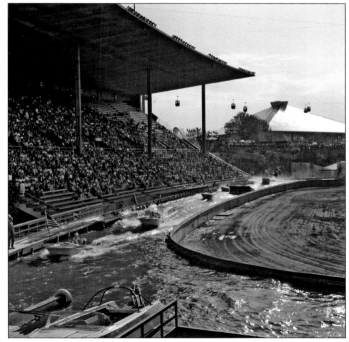

The main attraction in the stadium was the free *It's the Water* show, featuring trick water-ski acts. Sponsored by Olympia Brewing, the show was produced by Tommy Bartlett, who operated a very popular water-skiing show in the Wisconsin Dells. The show was a last-minute addition, with the contract signed just 20 days before the fair opened. It marked the first time a water-ski show was held in a site far removed from a natural body of water.

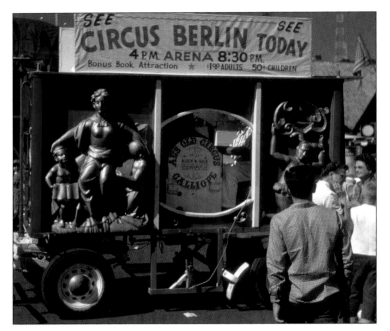

The other major tenant in the stadium was Circus Berlin. Well before the days of Cirque du Soleil, Circus Berlin confused most American visitors who were expecting a more traditional show with lions, tigers, and elephants. Attendance was light due to disappointing reviews and a separate admission fee, one of the few charged at the fair. It probably also did not help that there were plenty of spots to watch the show for free from outside the stadium.

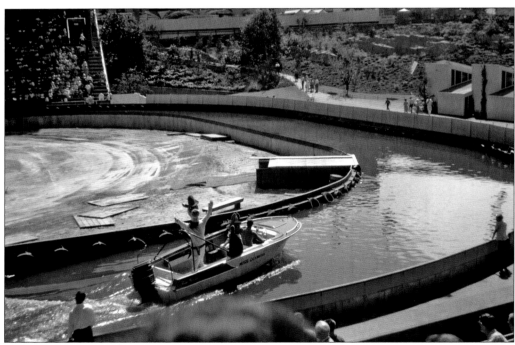

The stadium was also used for a number of other events, including the fair's opening and closing ceremonies. A less formal but well attended show featured the popular Hanna-Barbera cartoon characters, including Quick Draw McGraw and his faithful sidekick Baba Louie, seen here taking a spin in one of the boats from the ski show. Considering the space-age look of the fair, one might have expected the stars of *The Jetsons* instead.

The large amount of space underneath the stadium was also put to use. Approaching from this angle, it appears to be the location of the fair's Show Street section; in actuality, it was an area known as Exhibit Fair. One of the least interesting sections of the fair, it contained a hodgepodge of vendors hawking their wares. The only redeeming feature was its shortcut to the real Show Street.

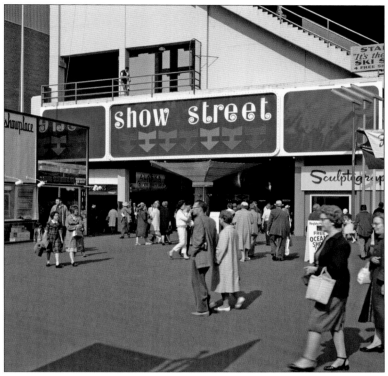

Just outside the stadium was the Spanish Village. The restaurant and shops were popular, but the real draw was free flamenco dance shows. The village ignited a war with local unions for its use of staff brought in from Spain for the fair; a judge agreed that there was a legitimate grievance as far as the restaurant staff but ruled that the dancers were unlikely to harm the careers of any local flamenco performers.

For some reason, this area also included the Plywood Home of Living Light. It was built by the Douglas Fir Plywood Association, which proclaimed it as the solution to building more houses on smaller lots. The curved design was intended to maximize the amount of housing that would fit on a property, with skylights that would rotate to capture sunlight. The skylights could not make up for the lack of windows, though, and the design never took off with would-be buyers.

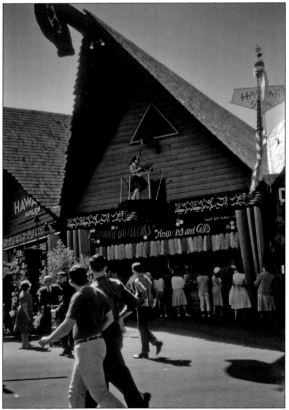

Hawaii was also located in this section. Travel to Hawaii was a relatively rare experience in 1962, but as the newest state at the time, it was determined to rectify that. While most of the state exhibits at the fair focused on the business opportunities they offered, the Hawaii pavilion was almost exclusively devoted to tourism. Guests could sample Hawaiian foods and beverages, enjoy entertainment from hula dancers, and buy a wide range of souvenirs, including leis and colorful clothes.

Six

THE BOULEVARDS OF THE WORLD AND FOOD CIRCUS

As any parents who have taken their families to a theme park or world's fair can easily attest, there are plenty of ways to spend money once inside the front gate. The same was true at the 1962 Seattle World's Fair. Most of the shows and attractions were free, but there were also plenty of shopping and dining possibilities for those with a big enough budget.

Shopping at this fair was a markedly different experience from most world's fairs. There was a large selection of souvenir merchandise like the others—hats, shirts, ceramic figures, and so on, all festooned with the Space Needle or the fair's official logo—but there was also a tremendous variety of handicrafts from around the world. These items were sold from small shops clustered together to form what were dubbed the Boulevards of the World. There was no rhyme or reason as to how the shops were grouped; part of the fun was wandering from store to store and making new discoveries.

Dining at the fair could also be an entertaining experience. The fair was set in the days before massive chains dominated the fast-food industry, and as a result the fair's food outlets were mostly run by small mom-and-pop outfits. Many of these small ventures would not have been able to afford the costs of building their own stand-alone shops, but the fair offered them a solution: the Food Circus, housed inside a massive building that had proven problematical in the design of the fair.

Built in 1939, the building had been the Washington National Guard Armory. The structure filled an entire city block, which was a sizeable portion of the fair site, and local and state leaders refused to allow it to be torn down for the fair. It was decided that rather than having small food stands strung throughout the fair, most would be housed in the former armory. The practice was novel at the time; today, food courts are commonplace across the country.

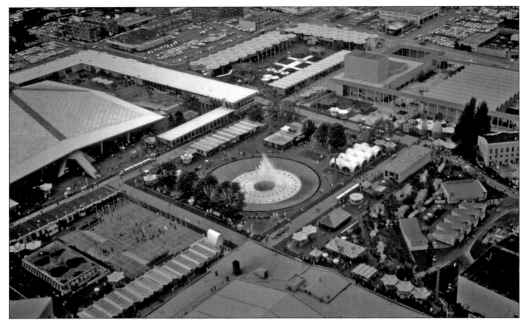

Much of the Boulevards of the World section was located near on the International Fountain (center), near the Plaza of the States on the lower left and bordering the international pavilions near the top. The large building at the bottom center was the Food Circus.

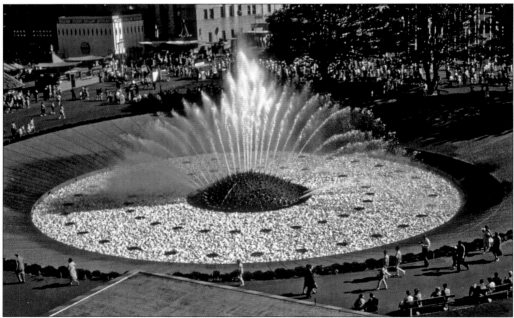

The first to use a sophisticated computer system that controlled 117 nozzles that could blast water 100 feet into the air, the International Fountain was a marvel of its time. The computer was used to coordinate the movements of the fountain and its surrounding lights to music. Fencing and warning signs, along with a field of jagged rocks, kept visitors away from the fountain lest they hurt themselves on the spiky nozzles; a 1995 renovation made the area much more accessible.

The Plaza of the States presented the flag of each state. A plaque at the base of each flagpole provided details on the state, such as its size, capital, and date admitted to the United States and the official bird, flower, and tree. The area was also used for numerous ceremonies held by the fair corporation to honor special state days, visiting dignitaries, and groups.

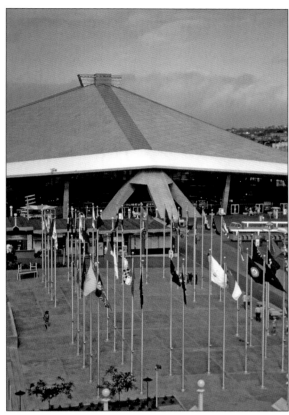

The Seattle World's Fair Band performed at many of these events. Here, they are taking part in a celebration of the 60th anniversary of the Automobile Association of America. The band's most famous performance was the finale of *It Happened at the World's Fair* in which Elvis Presley led them in a lively march across the grounds.

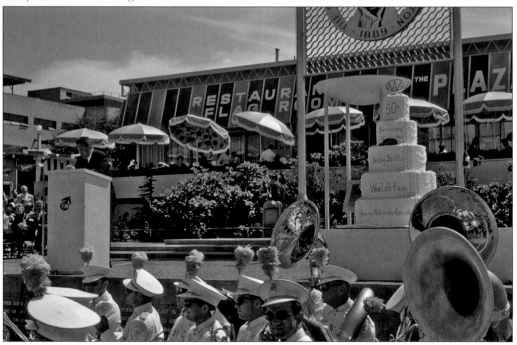

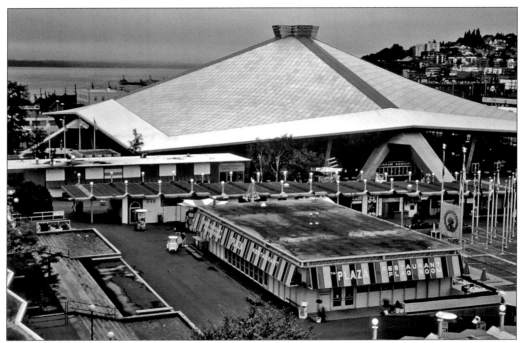

The Plaza Restaurant was one of several restaurants in the Boulevards of the World area. The moderately priced venue was popular because of its location near the center of the fair. The plain-looking building was an unlikely survivor of the post-fair demolition that razed so many of the other structures; it was finally removed in 2001.

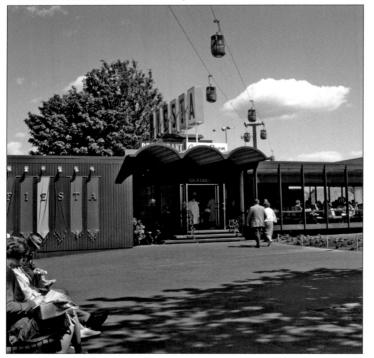

The large windows of the Fiesta Restaurant provided diners with unobstructed views of the International Fountain. The restaurant's Cantina Room was a popular spot to enjoy a cocktail after a long day at the fair. Cars of the Union 76 Skyride can be seen passing overhead.

Alcoholic beverages also played a large role at the Hofbrau Haus. Signs prominently displayed at the entrances warned, "Positively No Minors Allowed Except on Sundays." Local laws prohibited the sale of alcohol on Sundays, making it safe for the kiddies to venture inside for some Wiener schnitzel and sauerkraut.

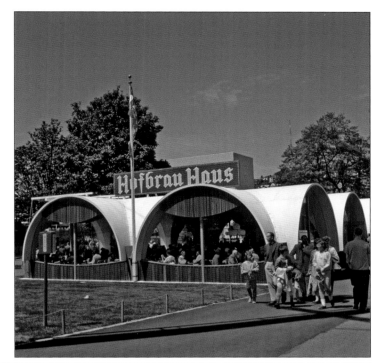

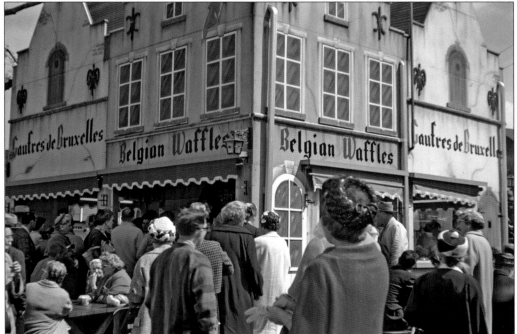

Belgian waffles can be found today at countless locations across the country, but in 1962 the only place in the United States where one could be enjoyed was at the Seattle World's Fair. A lighter and fluffier version soared to fame at the 1964–1965 New York World's Fair, but the tasty treat actually made its American debut in Seattle—a handy thing to know in a trivia contest!

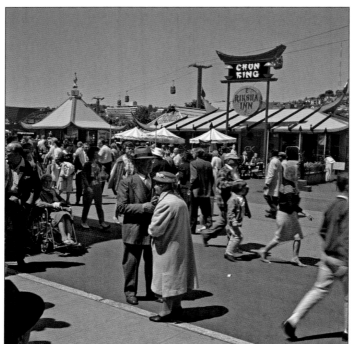

Two well-dressed visitors pause for a moment near Chun King's Ricksha restaurant. Families found the place especially inviting because a full meal and beverage was only 99¢. In 1962, Chun King was said to be selling 50 percent of all frozen Chinese food in the country; the restaurant was an experiment to see if the brand was successful outside the home. It certainly was a hit at the fair.

There was more to do in this section of the fair than just eat. The other real attraction was shopping, with a dizzying array merchandise from around the world. Shops like the gaudily colored Toyland offered American products as well, but they were a distinct minority. Mostly, they were relegated to the Exhibit Fair under the stadium so that this section would have an international flair.

The brightly colored facades disguised the fact that most of the shops were little more than plywood stalls. Low-cost structures such as these made it possible for small vendors to participate in the fair, thereby adding an additional level of excitement. The Seattle fair was unique in that aspect, as most fairs have featured a smaller number of shops from larger retailers.

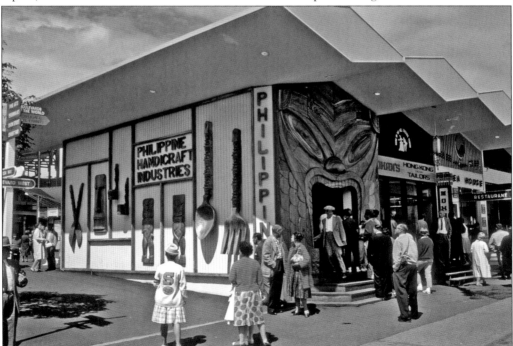

A little ingenuity went a long way toward luring would-be shoppers inside. Who could resist the thrill of walking inside this giant wooden mouth? Next door a tailor offered custom-made suits from Hong Kong, and next to that was a small Korean snack bar. All these shops were operated independently from the international exhibits in the World of Commerce and Industry section.

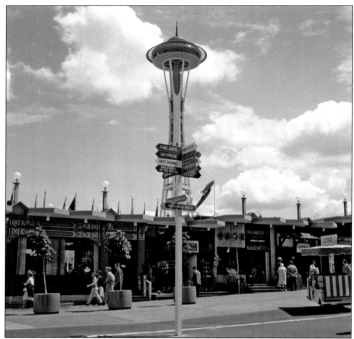

Most of the shops were operated by companies created just for the fair, but some had long ties to the Seattle area. The Uwajimaya shop, shown here between the sign post and the Electricab, was founded in 1928 and today operates four stores in the region.

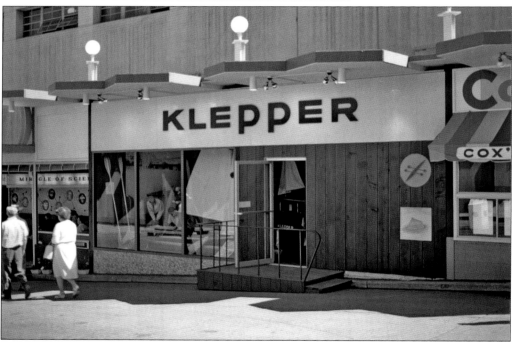

Those interested in kayaks or small boats could browse through a selection at the Klepper shop, operated by another local merchant. Would-be sailors had to wait for their crafts to be delivered later at home, for the boats were not available for pickup at the fair. Shoppers who needed instant gratification could pick up model cars, boats, and airplanes at the Cox shop to the right. The imposing wall in the back was part of the Food Circus.

If shoppers exhausted themselves but not their wallets, for 50¢ they could hop on board one of the Fairliner trams that crisscrossed the grounds. Children were an even better bargain at only 25¢. Unlike the Electricabs, which operated more like taxis, the Fairliners ran on predetermined schedules on set routes. They were an excellent way for newcomers to get a quick orientation of the fair.

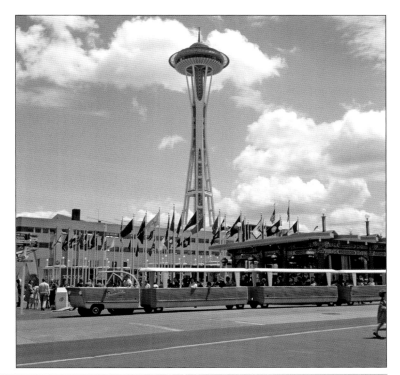

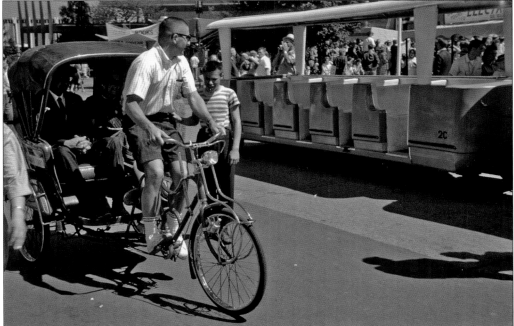

Human-powered pedicabs also offered a way to get around the fair in comfort. Many of the shops in the Boulevards of the World were on a rather steep hill that made the drivers have to really work for their tips. Eagle-eyed readers may spot a small generator on the front wheel that was used to light the headlight at night.

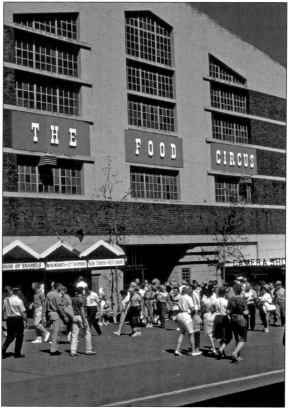

Looming above the Boulevards of the World was the massive bulk of the Food Circus. The building stood four stories above ground level, much higher than most buildings at the fair, with three more levels below grade. In addition to being used as a dining facility, the building also housed dressing rooms for visiting performers, storage facilities, and office space.

Historians are unsure who first coined the phrase, "You can put lipstick on a pig, but it's still a pig." If the saying was not in use in 1962, it should have been, for the Food Circus was an ungainly pig plopped in the middle of the fair. There was not much that could have been done to make the building more attractive, so the organizers added a few brightly colored signs and hoped that would be enough.

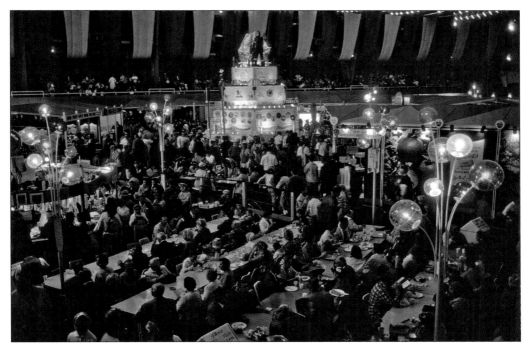

A total of 52 vendors were located inside the Food Circus. Colored banners hung above the dining area, both for visual appeal and to mitigate sound problems within the cavernous room, but the noise level and echoes were still often quite intense. Seating was often a problem as well, for as big as the building was, the designers put in a woefully small number of tables.

Standing tall over the diners was Paul Bunyan's Birthday Cake, billed as the world's largest cake. The 25,000-pound fruitcake was 23 feet high and was decorated with a candle for each of the 50 states, plus an extra one for Seattle. Slices were available for purchase and included a mailer to send as a souvenir. The dark notch on the left marked the ceremonial first slice cut by Ethel Rossellini, the governor's wife.

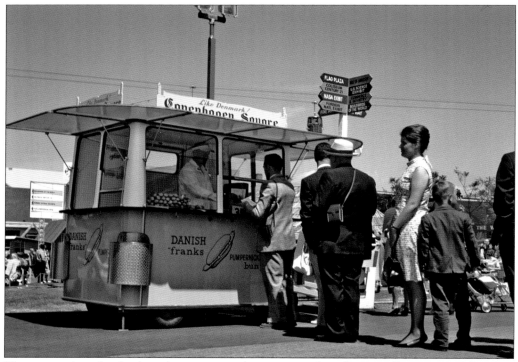

There were also a few food vendors operating from carts, such as this one offering Danish hot dogs on pumpernickel buns. A close look at the signpost shows the fair could have used a spell checker; the word "exhibit" was spelled incorrectly several times. That problem was repeated across the fairgrounds and required a hasty correction when embarrassed officials realized the mistake.

There were also several booths operated by franchisees, representing the start of a trend that would soon revolutionize the industry. With all the food choices available at the fair, it is hard to imagine that anyone went home hungry, especially when looking at the posted prices.

The fair promoted another way to dine, which tied into its space-age theme. Clusters of vending machines provided a wide range of meals, both hot and cold. There was also candy, ice cream, frozen shakes, and reflecting the times, cigarettes. Taken for granted today, one revolutionary device received more press coverage than the food machines—a dollar bill changer.

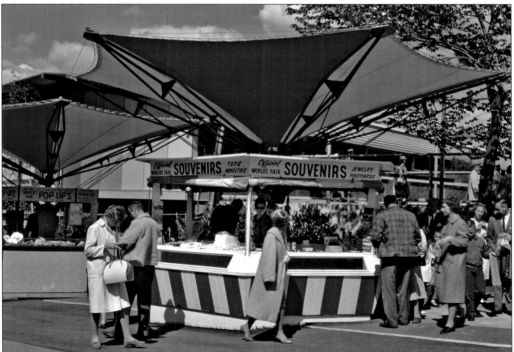

Small stands like this one offered temptations other than food. Some of these souvenirs are in high demand with today's collectors, commanding prices that would have been impossible to believe during the fair. The lengths that collectors and fans will go to as they try to recapture their memories shows how large an impact the fair had on many of the millions who attended.

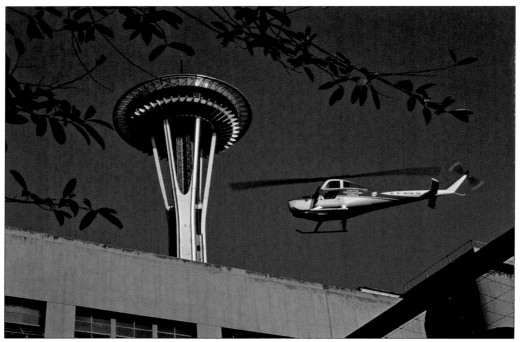

There were also several industrial displays in this area. In 1962, many aviation experts were predicting that personal helicopters would soon be a part of everyday life. Cessna, long popular for its light airplanes, hoped to be a major player in that market with its new Skyhook helicopter. A heliport was built atop the Food Circus, and aerial tours of the fair and other local sights were sold. The hoped-for sales fizzled, and the helicopter was discontinued shortly after the fair ended.

Most people have never been near $1 million in cash, but the fair provided an opportunity to get up close to a massive pile of silver dollars. The display was provided by the Behlen Manufacturing Co., which hoped to prove that if its wire enclosures could hold 30 tons of coins, they would be perfect for farming needs.

Seven

SHOW STREET AND THE GAYWAY

For all their lofty aspirations and bold predictions for the future, many earlier world's fairs had hosted crude adult-oriented sections. Some fairs were infamous in this regard; for example, shows featuring nude dancers were some of the biggest successes of Chicago's 1893 Exposition (Little Egypt), its 1933–1934 Century of Progress Exposition (Sally Rand), and visitors to the 1939–1940 New York World's Fair could tour a faux nudist ranch and see adult-rated sideshows. Knowing how lucrative these ventures had been, it was inevitable that there would be promoters looking to cash in on the trend at Seattle's fair. It was also inevitable that many in the city would object.

Those worried that the fair's emphasis on science and art would be too highbrow might have taken comfort in an announcement from the fair's president that it "would have something for the boys." Others worried about that "something" were likely supporters of the Seattle Censor Board, which found itself quite busy during the fair. Some shows were deemed unacceptable and shut down, while others did their best to stay one step ahead of the police raids. All of this makes telling the story of Show Street a bit of a problem, as many of the exhibits were a bit too risqué for this volume.

The story of the Gayway, the fair's amusement zone, is a safer tale to tell. The fair organizers had realized that the event needed to be appealing to visitors of all ages, and with the Gayway, they provided a welcome diversion for many of the younger visitors, especially the teenage set. Looking much like it had been pulled out of a county or state fair, the Gayway was a brightly colored cornucopia of rides, carnival games, snack bars, and restaurants. The area proved to be especially popular at night; many of its rides adorned in bright lights spun wildly above the crowds. The Gayway was so successful that portions of it, renamed the Fun Forest Amusement Park, operated for almost 50 years after the fair closed.

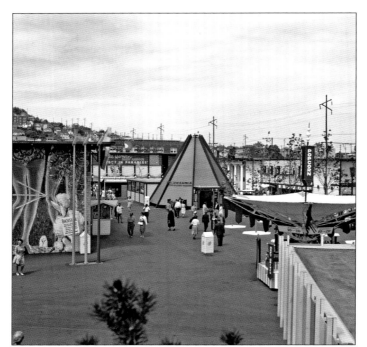

The Show Street area was deceptively innocent when viewed from the passing walkways; however, when visitors strolled into the plaza area, the adult nature of the zone started to become apparent. Three sides of the area were lined with buildings that advertised its adult entertainment. This was definitely not a spot to bring the kids.

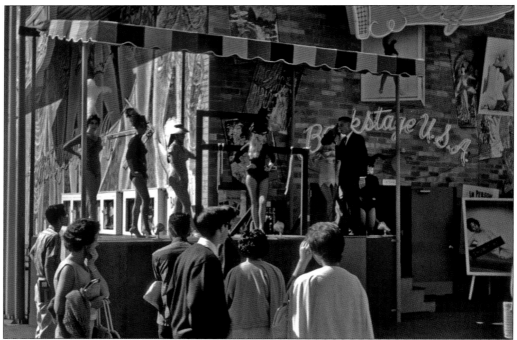

Just inside the entrance, Show Street revealed its true colors. Here, a barker tries to lure customers into Backstage USA. The show offered a look into what it was like backstage at a Broadway play or a Las Vegas review—that is, as long as the performers were all female and between costume changes. The show opened to negative reviews; female guests hated it, and the men felt the showgirls were overdressed. The producers responded by eliminating more of the costumes.

The most popular attraction on Show Street was the Paradise International nightclub. The 700-seat theater was home to Gracie Hansen's *Night in Paradise* show, a Las Vegas–style revue that featured topless showgirls. Many local churches and civic groups complained about the show, but that did not scare away the crowds that filled the theater almost every night.

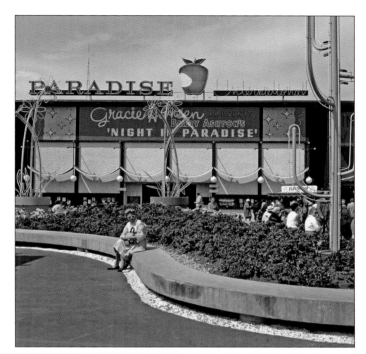

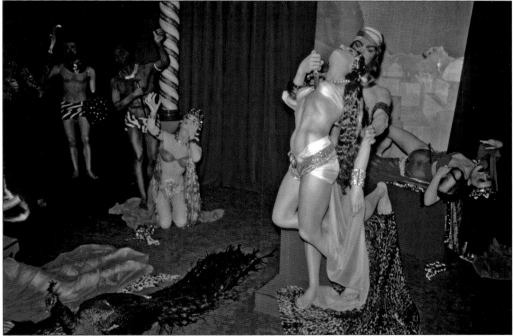

The Paris Spectacular Wax Museum had many tableaus that one would expect to find in a such an attraction, including The Last Supper and other religious icons, such as John the Baptist and Joan of Arc, as well as scenes from classic literature. One large section showed life at Versailles during the reign of Louis XV. The museum also featured barely clad harem girls, French cancan dancers, and some displays of rather violent and questionable content.

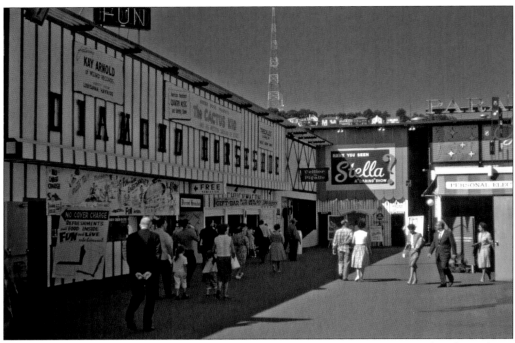

Not every show featured nudity. The Diamond Horseshoe, for example, included a lineup of country stars from the *Louisiana Hayride* radio show. Just past it, though, a large sign asked, "Have You Seen Stella? A 'Daring' Show." If the sign left any doubt about the type of show it was, the question was answered by a large photographic display next to the door.

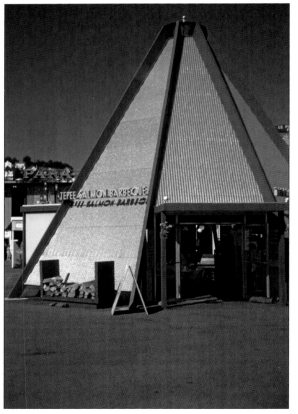

In the center of all this stood the Tepee Salmon Barbeque restaurant, easily the calmest section of all of Show Street. With salmon being such an important product of Washington State, it is surprising that it was not more heavily promoted at the fair.

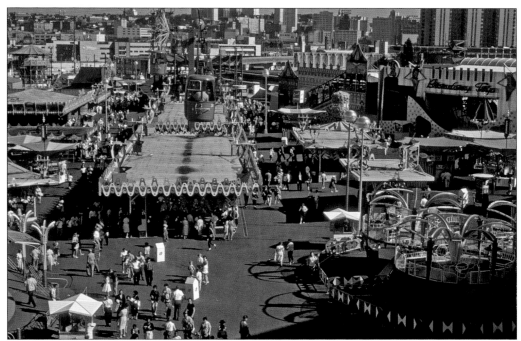

Children might not have been welcome at Show Street, but the Gayway more than made up for the snub. Seen here from the Union 76 Skyride is just a portion of the rides, carnival games, and snack bars that filled the area. More than $2 million was spent on the Gayway, which the fair proclaimed as having the most modern rides in all of North America, many just imported from Europe for their American debut.

Many fairs have Ferris wheels, but Seattle had one that had never been seen before. The brainchild of Curtis and Elmer Velare, long famous for their innovations in the attractions industry, it suspended riders far out from the central axle in 16 brightly colored cars at the end of long arms. The wheel was not ready for opening day, but when completed it was a hit with the crowds.

Calypso was one of the new rides imported from Europe for the fair. The ride was much more of a thrill than those seen before, and it was a big hit. Each group of four cars rotated at high speeds on a platform that also spun around, making it a dizzying experience indeed. Variations of it can still be found in use today at carnivals and amusement parks across the country.

A traditional carnival "dark ride" turned out to be a surprising hit at the fair. Perhaps it was the out-of-this-world artwork or the menacing yet laughable monsters inside, but Flight to Mars had lines longer than many of the pavilions and shows. Amazingly, the ride long outlasted the Gayway, staying in the post-fair park until 1996, when it was finally moved to a different amusement park.

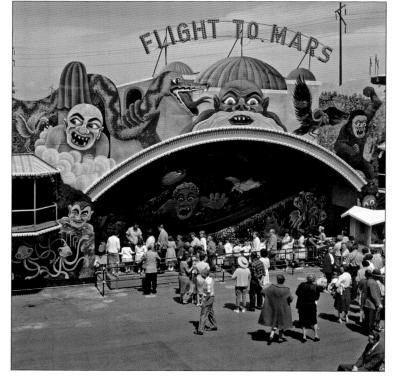

The fair site was too small to accommodate a traditional roller coaster, but the Wild Mouse ride more than made up for it. Another of the European imports, it took riders through a series of high-speed turns rather than down the long drops of most coasters. Microsoft co-founder Bill Gates counts it as one of his favorite memories of the fair. At left is the entrance to the Japanese Village, a collection of shops and snack bars with a separate admission fee.

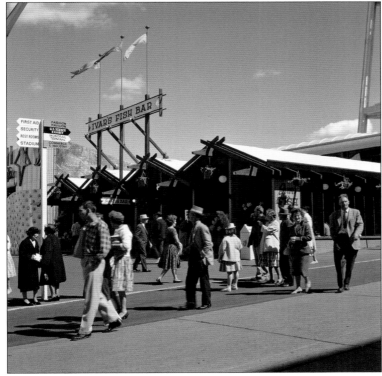

Ivar's Seafood Restaurants have been part of the Seattle landscape since 1938, so it was inevitable there would be one at the fair. Bamboo poles and exposed wooden beams gave it a tropical island look, and the interior was decorated with collages made from driftwood and seashells, some of which have survived and are now used in the company's Salmon House restaurant. Hamburgers and shakes were added to the menu during the fair in response to diners' requests.

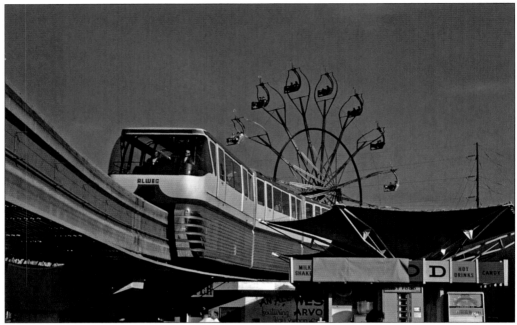

Of all the rides at the fair, none was more popular than the Alweg Monorail. It was hailed as the first monorail to operate in a city environment in the United States, with predictions that systems like it would be commonplace in just a few years. Still in use today, it remains the only urban system of this nature.

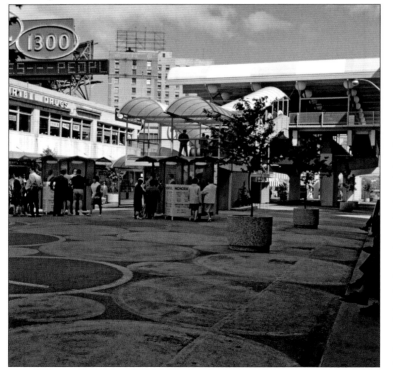

The monorail connected the fair with a new terminal in downtown Seattle. The area has since been redeveloped and the station greatly reduced in size, but a ride on the monorail remains a must for most tourists, as well as for residents looking for a convenient way to get to the Seattle Center park built on the former fairgrounds.

As the fair neared its final days, newspapers ran large advertisements reminding readers that there was still time for one last visit. On October 21, 1962, the great fair was over. There are many ways to judge a fair's success, and amazingly the 1962 World's Fair excelled in all of them. It had been built on time and on budget, it attracted more than the predicted number of paying customers, and unlike most fairs, it actually generated a small profit. The biggest measure of success, though, is what the fair left behind other than an impressive set of numbers. The Seattle Center, with its wide-open spaces, revitalized International Fountain, vibrant arts center, and of course, the still-graceful Space Needle and beloved monorail, is probably the most utilized and appreciated of all former fair sites. Just as the creators of the fair had hoped for back in the 1950s, the fair changed their city for decades to come. Everyone associated with the fair can justifiably be proud of the legacy they created.

Discover Thousands of Local History Books
Featuring Millions of Vintage Images

Arcadia Publishing, the leading local history publisher in the United States, is committed to making history accessible and meaningful through publishing books that celebrate and preserve the heritage of America's people and places.

Find more books like this at
www.arcadiapublishing.com

Search for your hometown history, your old stomping grounds, and even your favorite sports team.